WASHINGTON DC
THROUGH TIME

FRANK MUZZY

AMERICA THROUGH TIME®

AMERICA THROUGH TIME is an imprint of Fonthill Media LLC

Fonthill Media LLC
www.fonthillmedia.com
office@fonthillmedia.com

First published 2013

ISBN 978-1-62545-049-4

Typeset in Mrs Eaves XL Serif Narrow
Printed and bound in England

Connect with us:
🐦 www.twitter.com/usathroughtime
f www.facebook.com/AmericaThroughTime

AMERICA THROUGH TIME® is a registered trademark of
Fonthill Media LLC

INTRODUCTION

Washington DC has a rich on-going story captured in paintings, drawings and, most of all, photography. The advent of this new medium, with the development of the camera and permanent images in England by Thomas Wedgewood in 1790, occurred at the same time as the creation of the Federal City on July 16, 1790.

The capital district along the Potomak (now Potomac) River pulled portions of the states of Virginia and Maryland under the exclusive jurisdiction of the US Congress, creating the capital of the United States.

The ceiling mural in the south wing of the Capitol depicts the location selection by President George Washington and the reviewing of plans with Pierre L'Enfant. Washington always referred to the capital as the "Federal City", but it was the three commissioners in charge of the development that so honored the President by naming the district after him in 1791. And as for "Columbia", it was the poetic word of the day for the United States, a bit of a tribute to the upcoming 300th anniversary of Christopher Columbus's discovery of America.

The growing city naturally inspired enthusiasts in the early forms of recorded imagery – its importance was clear, if not always the image.

Washington, the District of Columbia, was going to take its position as a world-class city, and it would be a photogenic one as well. As the capital flourished, most of the architectural creations were inspired by the Queen Anne, Châteauesque, Romanesque, Georgian revival, Beaux-Art and Victorian styles. Although even today, as new buildings rise from outdated ones, there appears to be an abundance of columns in the creations—the more massive the better. After the Civil War most of the row houses being constructed were in the Federalist and late Victorian designs. A few examples of this variety of architecture have remained into this new century, providing a fascinating living comparison of old and new.

With the advent of professional photographers, hobbyists and, as picture taking became simpler with the Box Camera, everyday enthusiasts, the number of photos chronicling the times increased vastly. Nowadays in the digital age, with the added features of cell phones, the images of life are comprehensive. One may surmise in the future there will be a photographic exhibit at the National Gallery of cell phone imagery, although many would be the self-reflected recordings of the photographer in a mirror.

Washington DC will never run out of subject matter and certainly tourists as well as townies will do their part as they have always done. The city is home to museums, marches, monuments, universities, foundations, embassies, and events – and history, be it the War of 1812, presidential inaugurations, political protests or moments of social change.

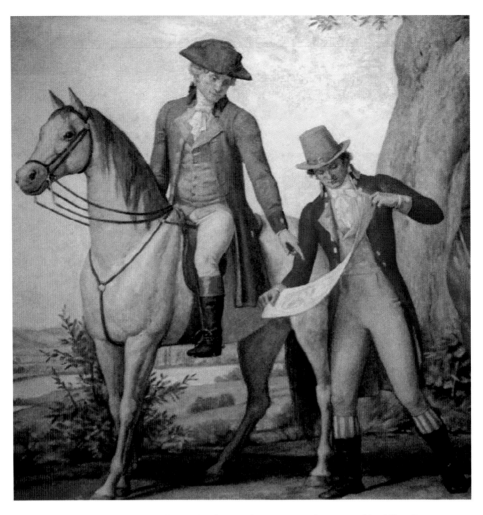

"Architect of The Capitol" from Capitol Selection Site, 1791, ceiling mural by Allyn Cox *c.* 1971.

These are what makes Washington DC the traditional "Main Stage of America", "Hollywood on the Potomac", and "Main Street USA". And, of course, all is well documented with the aid of history-saving imagery.

Washington DC Through Time is a broad stroke designed to whet the appetite and encourage one to look a little deeper into the wonder that is Washington.

It will allow the reader to step back in time to see what the city was like and compare it to how it is today. It is a photo journal examining the changes around the White House and the Capitol—with a protest or two thrown in for good measure—the emerging downtown, Georgetown—the oldest part of Washington—the C&O Canal, the bridges that cross over the Potomac, a city of circles and squares and neighborhoods tourists may rarely visit. It is also a collection of events unique to a city that is not just the seat of government, but an ever changing adventure, viewed not just by its own urban dwellers, but also by the rest of the country, and the rest of the world.

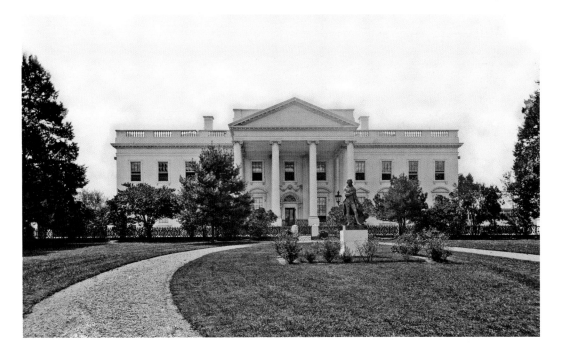

THE WHITE HOUSE: Since 1800 the White House has been the official home of the sitting President. Surviving fires, war, political intrigue, and scandals, it is also the principal workplace for the Office of President. In 1901, the famed west wing was added to accommodate the overcrowded workforce. Above is the 1864 White House of President Lincoln in a day when you could walk up and knock on the front door. Below, secret service can sometimes be seen guarding the grounds from the roof.

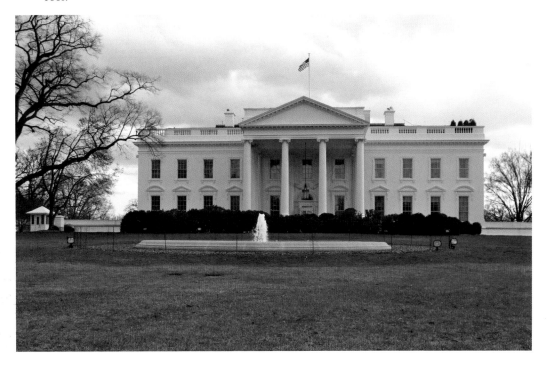

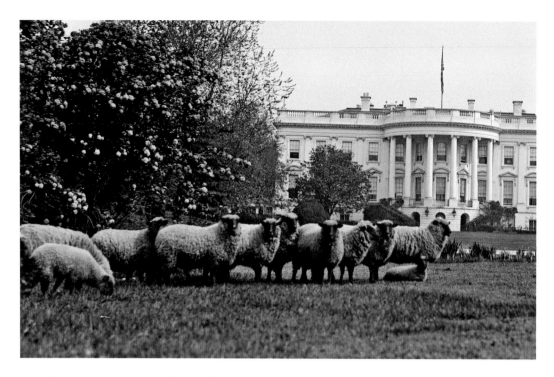

THE SOUTH LAWN OF THE WHITE HOUSE: Approximately eighteen sheep grazed on the South Lawn during World War I, keeping the grass cut and earning over $50,000 for the Red Cross's wool auction. Today, bees in hives do their part by pollinating flowers and producing 175 lbs. of honey for three different styles of White House Honey Ale.

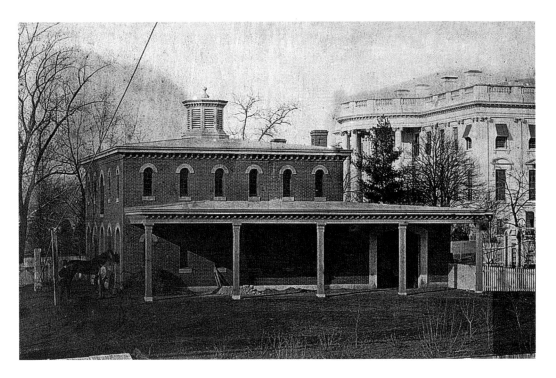

THE PRESIDENT'S STABLES: On the east side of the White House, facing the Treasury Building, were the stables, seen here in 1858 in the only known and recently found salt print by photographer of the period, Lewis Emory Walker. Built during the Buchanan administration, the stables are often referred to as the Lincoln stables after Lincoln himself tried in vain to rescue the horses when an arson fire destroyed the building in 1864. Today the approximate site is now used for the daily guest entrance, seen here on the left of the White House.

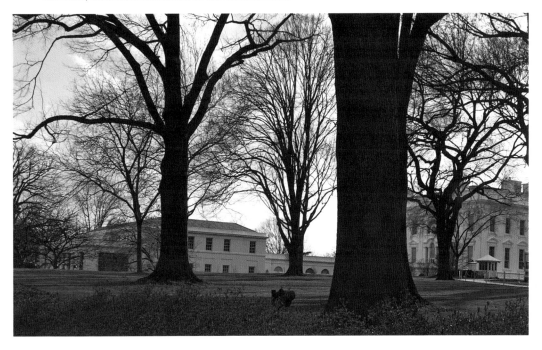

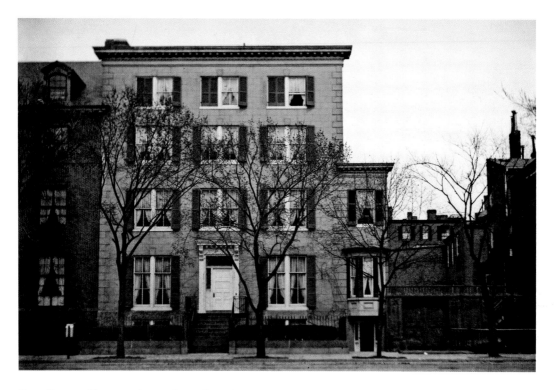

THE BLAIR HOUSE: Across from the White House, often reserved for visiting dignitaries and former visiting Presidents, is the Blair House, an example of the late "Federal Style", built in 1824. The Blair House of today, the official guest house of the President, is actually a combination of several houses amounting to 119 rooms with a square footage larger than the White House.

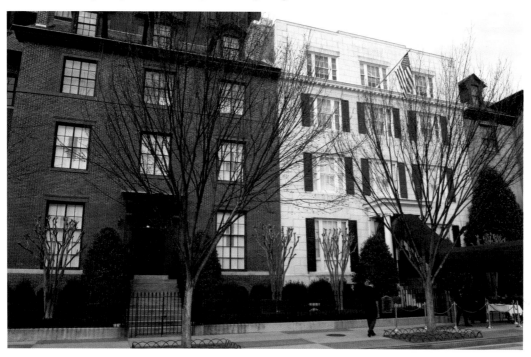

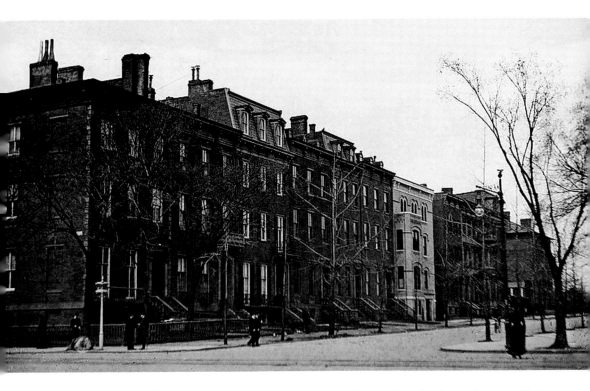

LAFAYETTE SQ. JACKSON PLACE: The row houses on the west side of Lafayette Sq. started being built in the late nineteenth century. The Decatur family, who had built their house on the far end early in the century, sold off the block in 1869, creating a building boom. The federal government eventually acquired the block and planned to demolish it for office buildings when First Lady Jacqueline Kennedy intervened and plans for restoration prevailed.

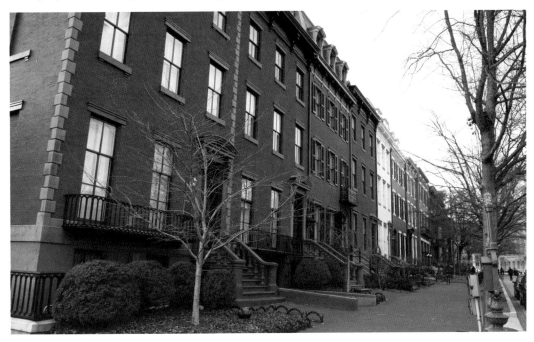

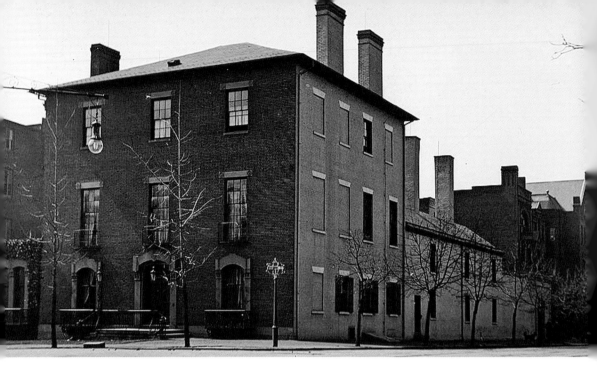

THE DECATUR HOUSE: In 1818, America's first professional architect, Benjamin Henry Latrobe, built Decatur House on the newly subdivided block after the War of 1812. Commodore Decatur had requested it to be built in the austere Federal style of the day, fit for entertaining as the first private residence on the President's Park (now, Lafayette Park), where he was sure to cash in socially on "Proximity to Power". Alas, the Commodore was mortally wounded in a duel fourteen months later. Today, the house is a museum.

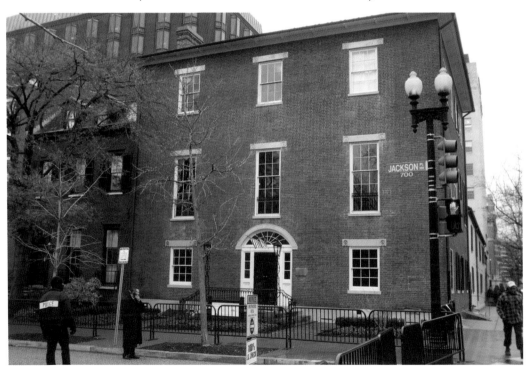

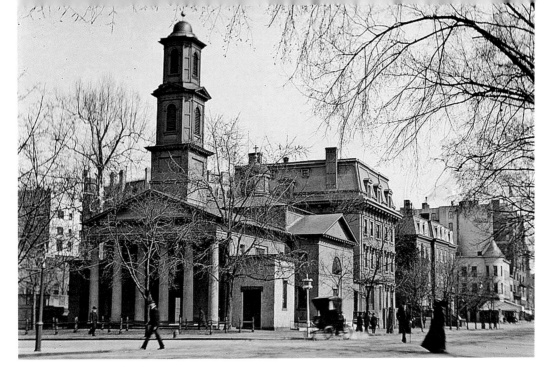

ST JOHN'S EPISCOPAL CHURCH: The church on Lafayette Square, across from the White House, also known as the President's Church, has had every President since James Madison in attendence, occupying the dedicated Pew #54. Constructed in 1815 by architect Benjamin Henry Latrobe, it was very much an anchor of early Washington Society and has survived all the urban changes.

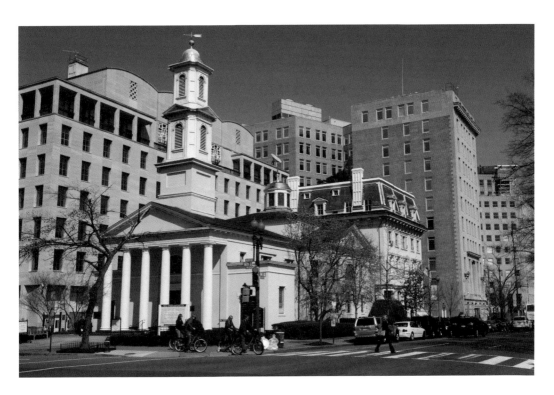

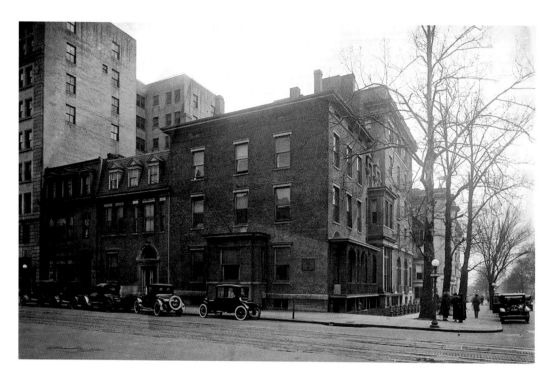

THE COSMOS CLUB: A private social men's club formed in 1878 for those who embraced and showed distinction in the arts and sciences. The National Geographic Society was founded within this club in 1888. By 1950, outgrowing the space, the club moved to the Townsend Mansion up on Massachusetts Avenue. The house itself was the former home of Dolley Madison and neighborhood lore reports her ghost can be seen in her rocking chair at the front.

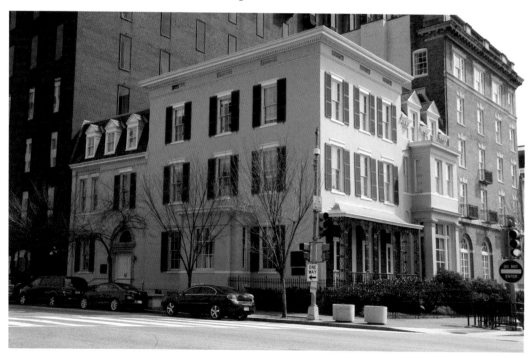

THE BELASCO THEATRE: Seen here on Lafayette Sq. in the 1920s, the Belasco Theatre was once, at the turn of the century, one of two main opera venues in DC. It became a movie theater in the '30s and eventually, during World War II, it was converted to the Stage Door Canteen to entertain serviceman on leave. In 1859 it was also the site of the shooting of Philip Barton Key II, son of Francis Scott Key, by the enraged Congressman Daniel Sickle for dalliances with his wife. For the murder, in plain view of pedestrians and the White House, Sickle got off on one of the first temporary insanity pleas. Today it is the site of the US Court of Claims, with restricted parking and much less drama; tourists easily pass by on the way to see the White House.

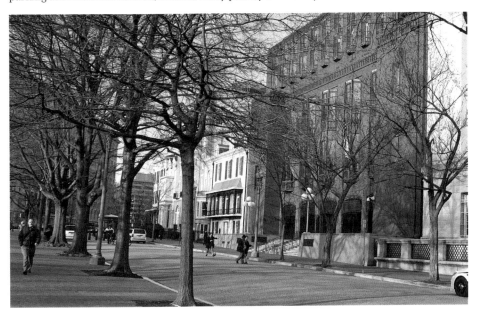

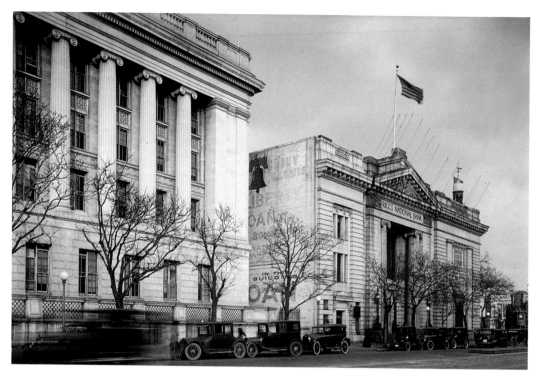

RIGGS & COMPANY: The 1830s saw the establishment of what was to become, according to their advertisement, "The Most Important Bank in The Most Important City in The World". Above, it is situated in 1919 across from the Treasury Building and down from the White House, and then below, today, with the street as a public plaza and the bank having been taken over by PNC.

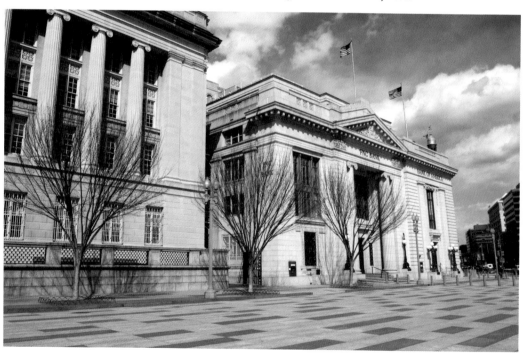

THE OCTAGON HOUSE: A 1925 look at the Octagon House located at 1799 New York Avenue NW. It was built between 1799 and 1801 and served as the temporary "Executive Mansion" for President Madison after the British burned the White House in the War of 1812. The "Federal style" octagon adapted to an irregular shaped lot and now serves as home to the American Institute of Architects. Below is a lad in front of the landmark promoting 51st statehood for the District, currently paying taxes without representation.

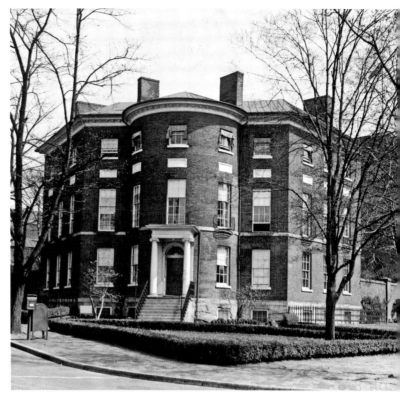

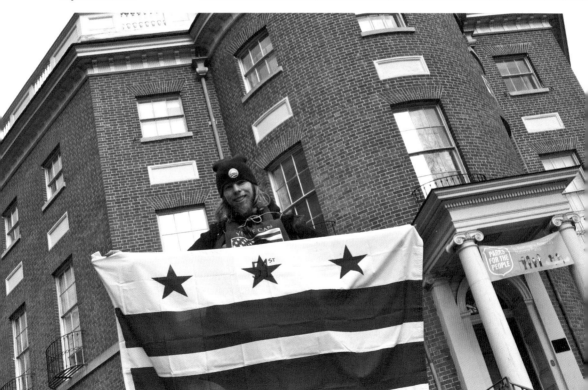

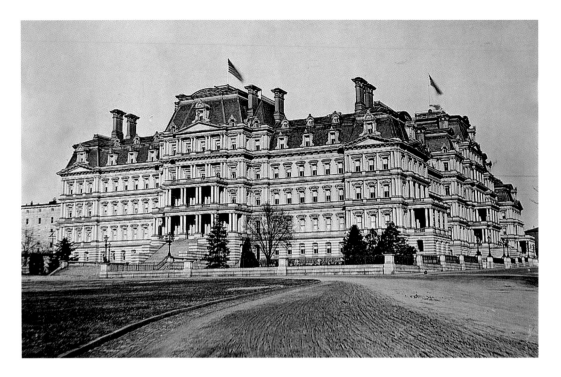

THE STATE, WAR AND NAVY BUILDING: Located on the west side of the White House on 17th Street, the State, War and Navy Building was built in the French Second Empire style between 1879 and 1888. Often referred to as the "Old Executive Office Building", it was renamed the Eisenhower Executive Office Building in 1999 and now houses, among others, the office of the Vice President of the United States.

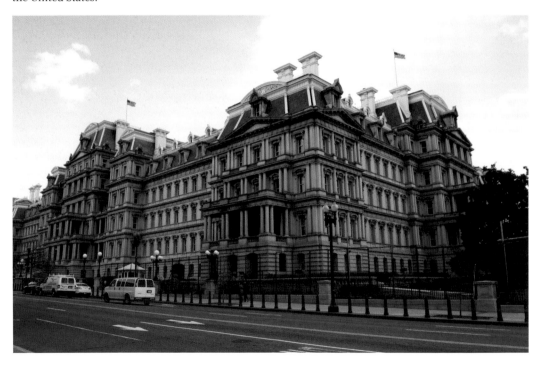

THE OLD WINDER BUILDING: Much as it looked in 1854, the Winder Building stands at the corner of 17th and F Street across from the Department of War, which it predates by more than twenty-five years. It was purchased back then by the government for offices for $200,000. Today, as the neighborhood has changed around it, the Winder Building remains under the wing of the National Register of Historical Places.

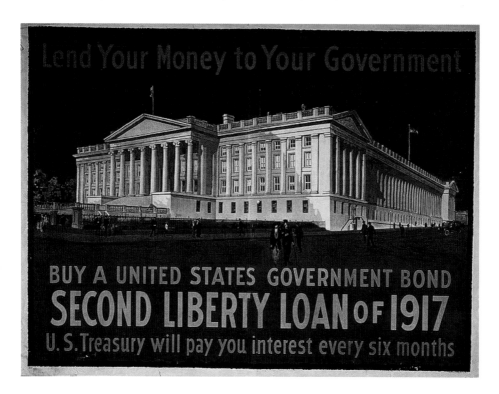

Lend Your Money to Your Government

BUY A UNITED STATES GOVERNMENT BOND
SECOND LIBERTY LOAN OF 1917
U. S. Treasury will pay you interest every six months

THE TREASURY BUILDING: Located just east of the White House, with a history of arson fires since 1800, the Treasury Building, seen here in a bond poster, has been rebuilt, enlarged, and visually fortified into a more formable structure. At one time there was an unobstructed view between the White House and the Capitol. Supposedly, President Jackson, in strained relationships with Congress, did not want to view the opposition out his window, hence the enlargement. Nice political theatre, but in reality the Treasury Building was just built on what was cheap and available government land.

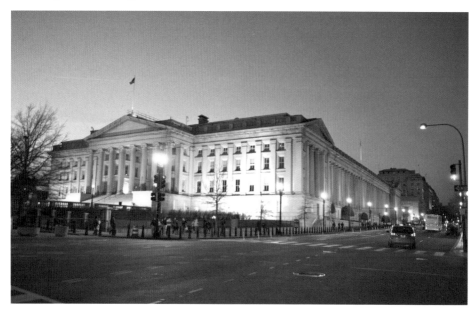

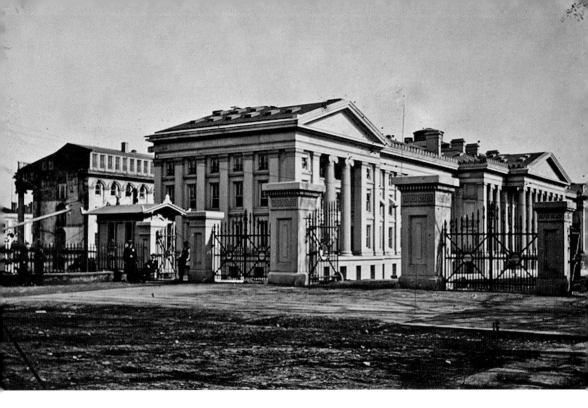

THE FOUR MAIN DEPARTMENTS: The State Department, the War Department, the Department of the Navy, and the Treasury Department were strategically adjacent to each other on lots around the White House. The Treasury Building, seen here mid-construction on its north side, at one time was the largest office building in the world and DC's oldest "departmental structure". Obscured behind many of these massive structured exteriors are the atriums providing light to inner configurations.

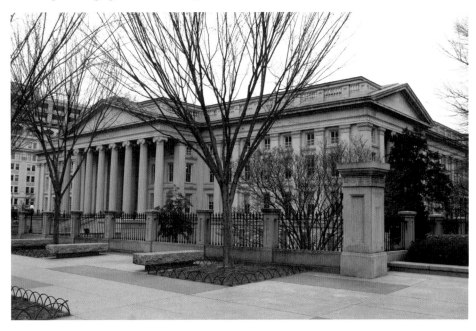

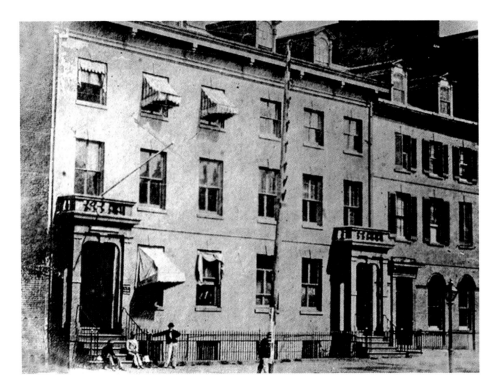

THE BUCHANAN / KING HOME: The 1830s shared home of James Buchanan and William Rufus de Vane King, at 1331 F Street, just around the corner from the White House. This was a power couple; King briefly served as Vice President (one month) in the Franklin Pierce administration, and Buchanan subsequently followed as President in the next term. F Street was quite a fashionable address at the time, and now rows of office buildings have replaced the rows of houses.

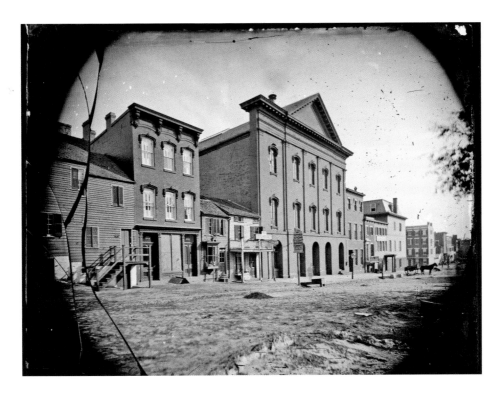

FORD THEATRE AT 10TH AND F STREET: It was during a performance at the Ford Theatre, seen here in a cracked glass negative, that President Abraham Lincoln was assassinated on April 15, 1865. Historians often refer to it as the last casualty of the Civil War, which had ended the week before. The stricken President was carried across the street from the theatre to the Petersen house, and there in the back bedroom he died the next morning with the street outside the house crowded with the concerned and weeping.

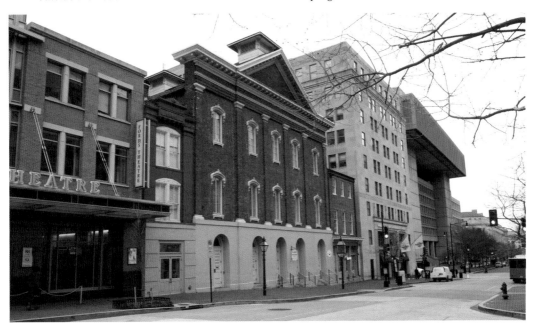

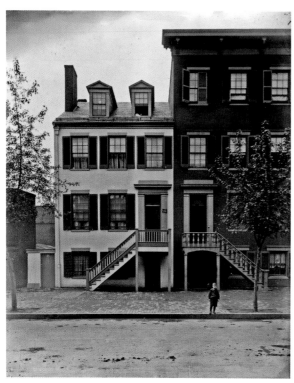

SURRATT HOUSE: Just blocks from the Ford Theatre, in 1865, is the rooming house of Mary Surratt, a Confederate sympathizer, at 604 H Street, where much of the plotting to at first kidnap President Lincoln took place. Frequent meetings between individuals, who had only met months before, would lead to a grand plot to assassinate several members of the President's cabinet as well as the President. John Wilkes Booth, an actor once touted as the handsomest man in America, would ultimately pull the trigger to end the President's life. Pursued by the authorities, he would not be taken alive. The rest of the eight conspirators would be brought to trial, convicted and hanged, making Mrs. Surratt the first woman in America to die at the gallows. At the trial she was said to have "kept the nest that hatched the egg".

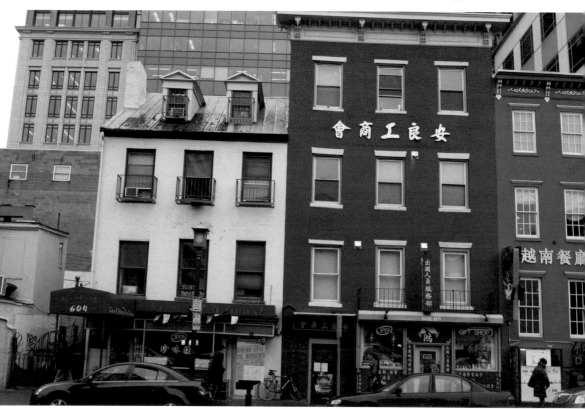

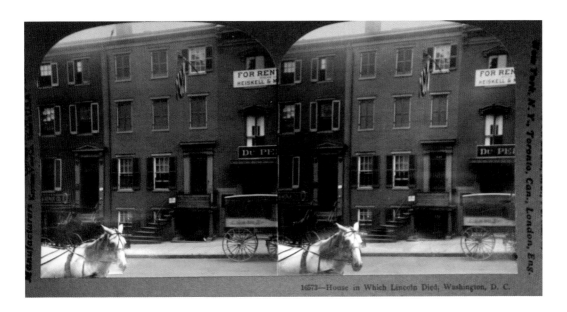

16573—House in Which Lincoln Died, Washington, D. C.

WHERE LINCOLN DIED: Across 10th Street they carried the stricken President from the Ford Theatre to the Petersen house, shown here in a stereo-optic soon after the event. Daily life on this street of horse-drawn carts would never be the same. Tourists would constantly knock on the door and ask to see the room where Lincoln died. Today, it is only slightly more organized, and tickets can be obtained from the Ford Theatre.

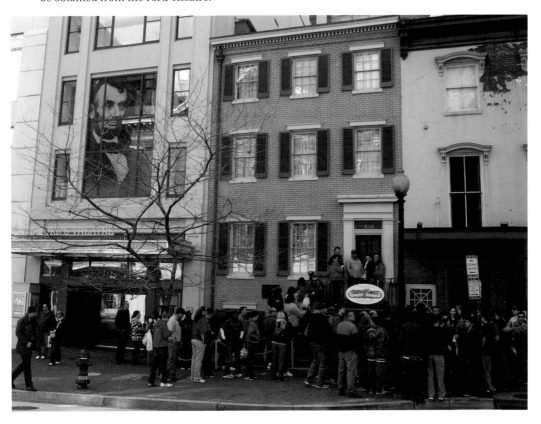

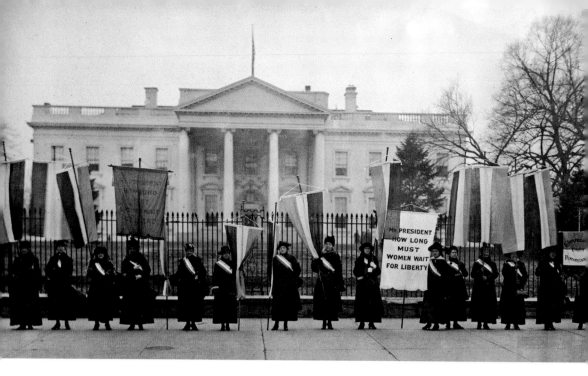

WHITE HOUSE LONGEST PROTESTS: Vigils in front of the White House are nothing new. Suffragettes try to get President Wilson's attention in 1917. Currently, Concepcion Picciotto has held her ground right in front of the White House since 1981, praying for peace and nuclear disarmament. She stands here in 2004 with the author, Frank Muzzy, flashing peace signs towards the White House commemorating her June 3rd vigil anniversary. The authorities move her encampment away to the other side of the square for Inaugural Parades every four years, but she still returns as soon as the reviewing stands come down. Documentarian Michael Moore spotlighted her in his film *Fahrenheit 9/11*.

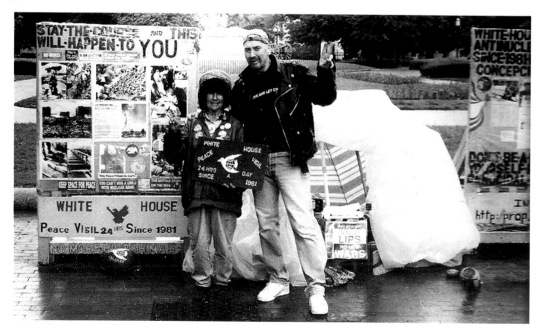

THE MARCH FOR EQUALITY:
High-profile spokespersons count on
the visibility they receive in Washington
DC to promote political causes, be they
voting rights for women, constitutional
rights for blacks, or in the twenty-first
century, gay rights. Here, Lady Ga Ga
takes a stand for the Marriage Equality
March, adding her celebrity to the event,
much as Susan B. Anthony did in the late
nineteenth century for votes for women
and the abolition of slavery. In both
cases, as with many others, dedicated
passion rallies the troops and hopefully
the attention of those who steer the ship
of state.

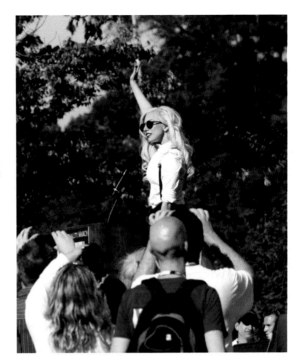

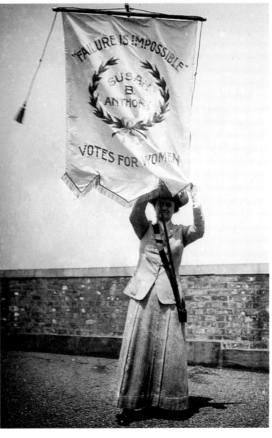

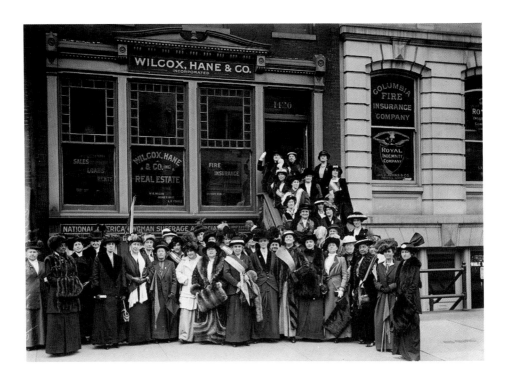

1420 F STREET: On January 2, 1913, Alice Paul and The National Woman's Party, dedicated to obtaining voting rights, rented the basement at 1420 F Street and set up headquarters. A block from the White House, the premises were chosen to be close at hand for daily protests and the March 3rd suffrage parade down Pennsylvania Avenue. A hundred years later the street would provide parking for guests staying at the Willard Hotel.

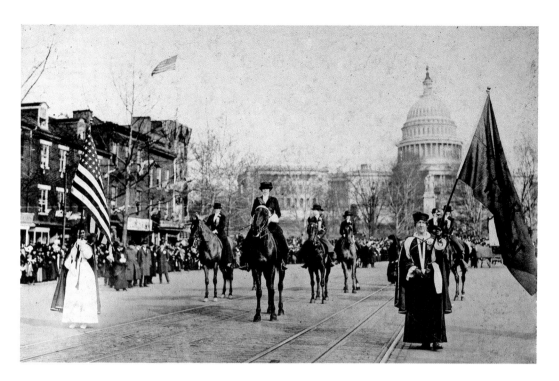

A MARCH DOWN PENNSYLVANIA AVENUE: Suffragettes proudly make their presence known, demanding the right to vote as they march in the March 3rd 1913 President Wilson inaugural parade. It took another seven years for the 19th Amendment to be ratified. Today, on this same spot, the Gay Men's Chorus of Washington DC perform for the ever popular Gay Pride Festival following the DC Pride Parade.

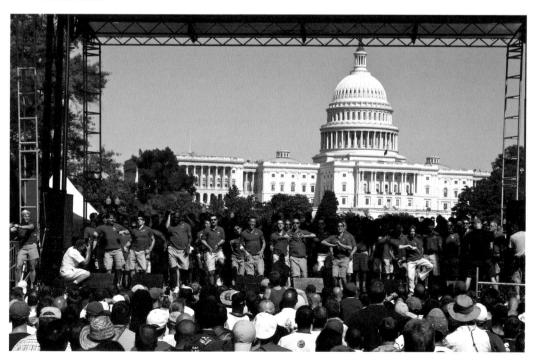

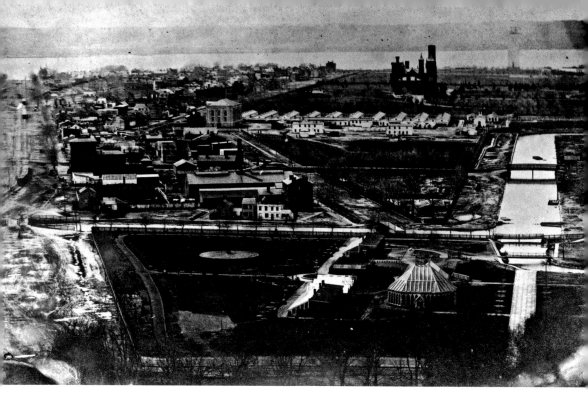

THE NATIONAL MALL: Barely recognizable in this 1863 image is the Smithsonian Castle and the newly started construction of the Washington Monument at the then swampy river's edge. Today, with the Washington Canal replaced by the long green space that stretches from the Capitol steps to the Lincoln Memorial, the Mall is able to serve as the nation's stage for inaugurals and other public events. Here in 2009, political activist David Mixner and actors Judith Light, Robert Desderio, and others address the assembled crowd.

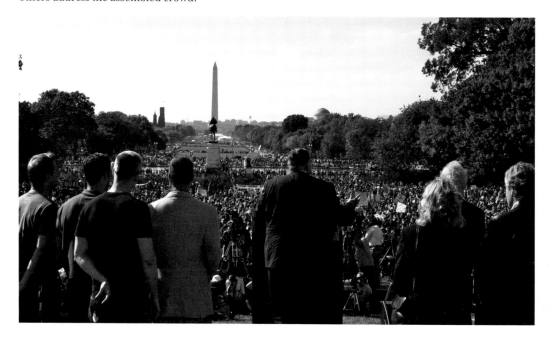

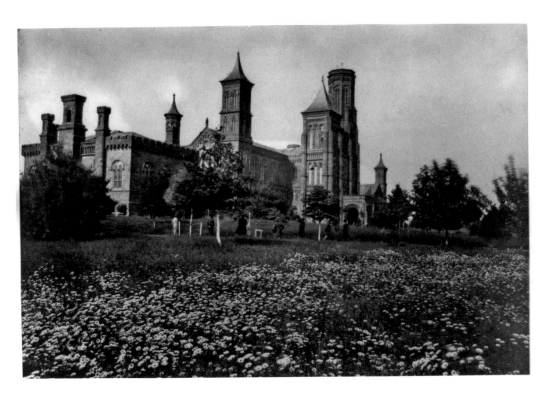

THE SMITHSONIAN INSTITUTE: The "Castle", established in 1846 with an initial bequest from English scientist James Smithson, was the first of nineteen museums in Washington DC, often referred to collectively as "America's attic". Mr. Smithson had never visited America but revered the new country. In 1905, many years after his death, his body was shipped across the Atlantic and placed in a crypt just inside the Castle's front door. The above photograph of a peaceful meadow from 1862 contrasts to today's picture with carousel music filling the air.

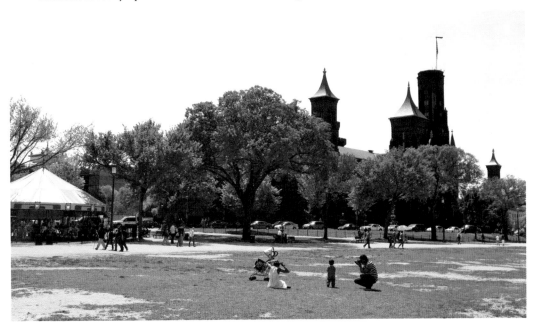

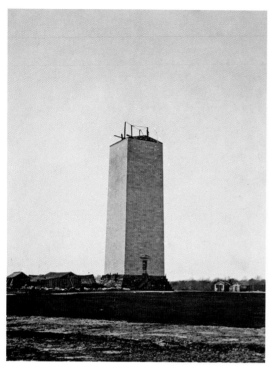

THE WASHINGTON MONUMENT, THE 1848 TO 1856 YEARS: There had always been a plan for a tribute to General Washington and the site was selected in the Federal City. The Robert Mills plan was a neoclassic obelisk surrounded by a circular colonnade supporting a chariot-driven Washington. Political rancor in the Washington National Monument Society and a take-over by the new "Know-Nothing Party", not to mention the Civil War, brought the construction to an abrupt halt; the monument remained for twenty years in this state. With a much altered design, including the pointed pyramidion, construction was resumed in 1876 and the monument was officially opened to the public in October 1888.

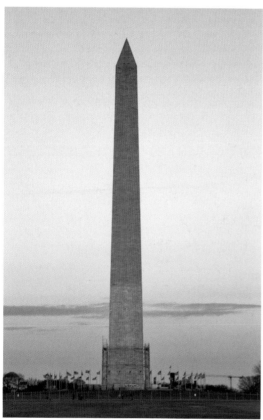

THE WASHINGTON MONUMENT, THE TWENTY-FIRST CENTURY: Seen here at the start of scaffold assembly for repairs after the August 23, 2011, earthquake. The change in color of the white marble brick at the 150-foot mark where the work stopped in the mid-nineteenth century is easily visible.

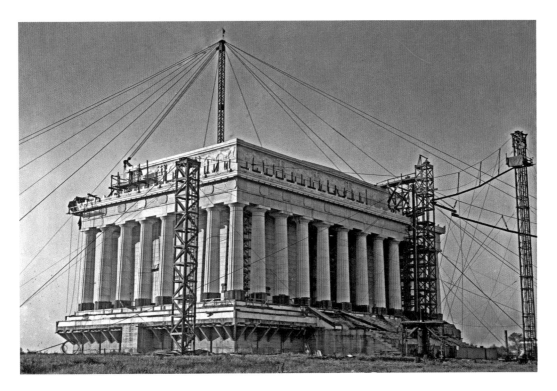

THE LINCOLN MEMORIAL: A memorial had been planned to honor the assassinated President since soon after his death. The original 1867 design called for six equestrian and thirty-one pedestrian statues of colossal size, and a 12-foot statue of Lincoln in the center. Lack of funds and taste derailed that project. Eventually, in 1910, Congress approved a bill for the construction of a neoclassical memorial and work began in 1914. The memorial was opened to the public in 1922.

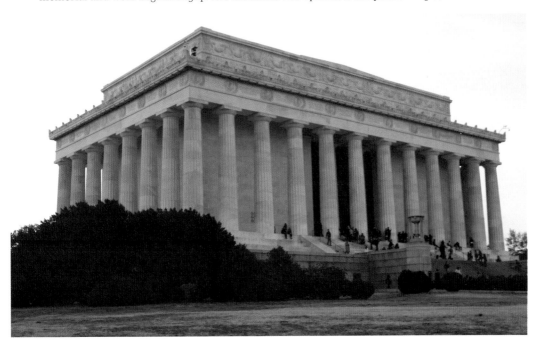

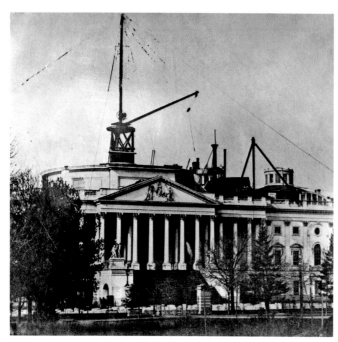

CAPITOL CONSTRUCTION:
The new Capitol construction commenced in 1825 and continued for the next thirty-three years. The sandstone Roman Corinthian columns on the east portico were installed early on, in 1828. They remained for 130 years, until it was determined that they were too fragile to support the new dome in 1958. They were replaced and then discarded for a while along the banks of the nearby Anticostia River. In the 1980s local support retrieved them out of warehouse storage and restaged them for full effect in the nearby Arboretum, at 3501 New York Avenue NE, below.

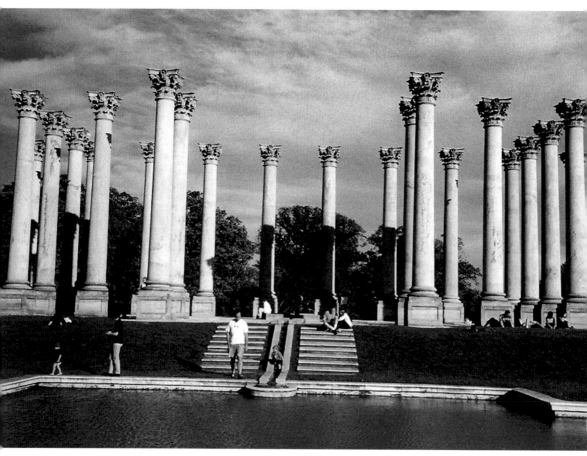

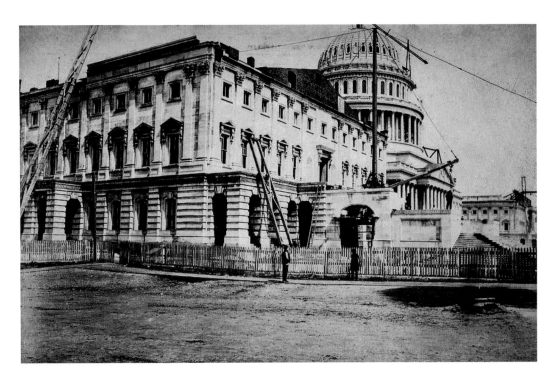

A HOUSE REMODELED: Although President Washington laid the cornerstone at the building's southeast corner in 1793, major expansion and remodeling was required in the 1850s to accommodate a growing number of senators and representatives for a growing country. A new dome and new southeast chamber wing, seen here, as well as a chamber of equal size on the north side, doubled the width of the Capitol.

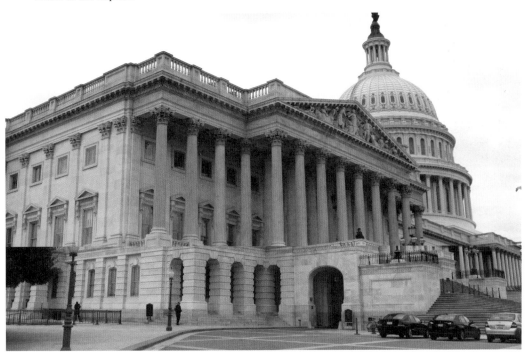

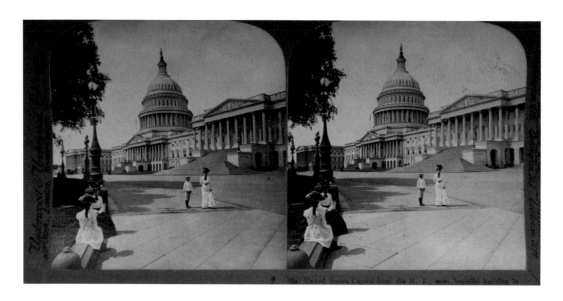

CAPITOL STEPS: A stereo-optic of the Capitol in Victorian times. These were dual-image card "collectibles" from one's travels. A hand-held viewer device would combine the card into a 3D single image, "like you were there" – a forerunner for the "View-Master" of contemporary images, available in some of the same tourist shops today. Those same stereo-optics have become a handy tool for viewing the past.

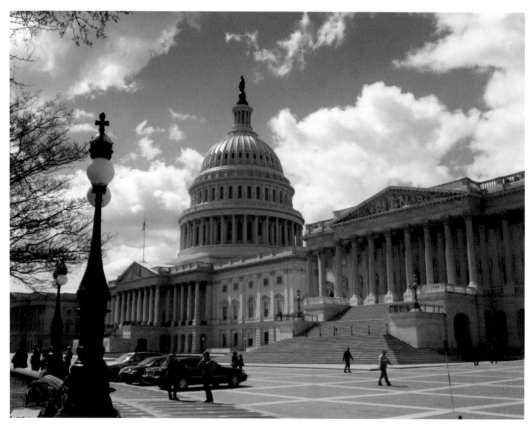

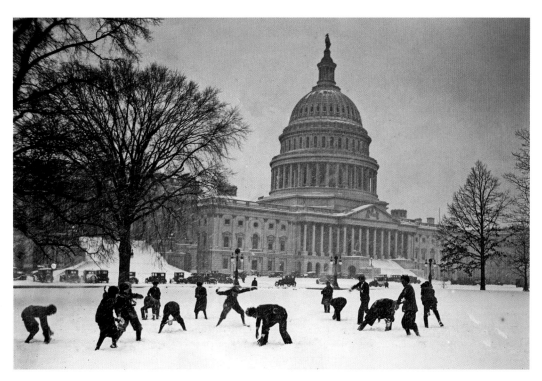

WASHINGTON DC HIJINKS: Senate pages take a snow-day break from the hustle on the Senate floor for a tussle on the snow-covered front grounds of the Capitol on January 2, 1925. In turn, since 2008, on the Annual International Pillow Fight Day, massive pillow fights have broken out in cities around the world. Usually the first Saturday in April, DC was part of the very loose and very playful urban playground event. No pillows or cameras were harmed...much!

NOTE: On this day, the scaffold still rising around the Washington Monument is for repairs from the earthquake of August 2011.

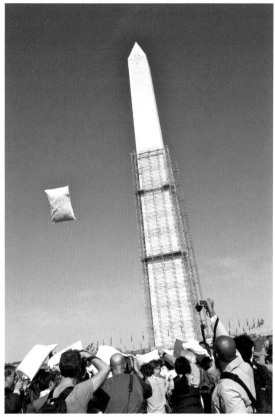

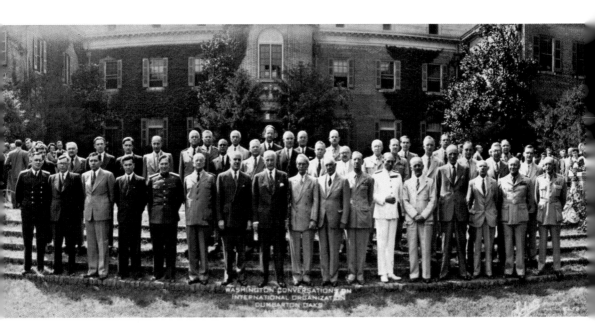

DUMBARTON OAKS AS THE WORLD MEETS: A panorama of "The Washington Conversations on International Peace and Security Organization" in the late summer of 1944, with world leaders gathering to discuss the formation of the United Nations. Today it is a gathering place of family and friends on a Sunday afternoon with time to explore the acres of formal gardens and paths that lead to many discoveries. An adjoining museum exhibits a collection of art through the ages.

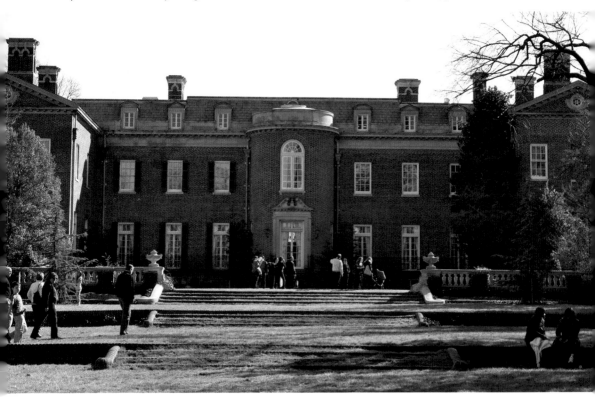

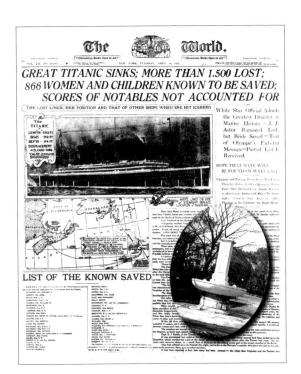

The World.

"Circulation Books Open to All." "Circulation Books Open to All."

VOL. LII. NO. 18,364. NEW YORK, TUESDAY, APRIL 16, 1912. PRICE

GREAT TITANIC SINKS; MORE THAN 1,500 LOST; 866 WOMEN AND CHILDREN KNOWN TO BE SAVED; SCORES OF NOTABLES NOT ACCOUNTED FOR

THE LOST LINER, HER POSITION AND THAT OF OTHER SHIPS WHEN SHE HIT ICEBERG

White Star Official Admits the Greatest Disaster in Marine History — J. J. Astor Rumored Lost, but Bride Saved — Text of Olympic's Fateful Message—Partial List Received.

HOPE THAT MANY WILL BE FOUND ON WRECKAGE

LIST OF THE KNOWN SAVED

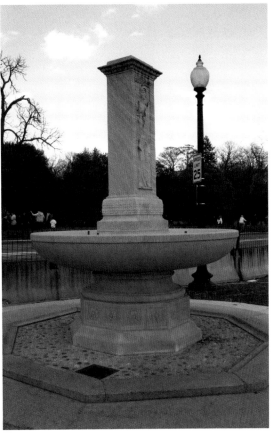

DC HEROES OF THE TITANIC:

Archibald Butt's housemate and friend, Francis David Millet, had accompanied him on that fateful voyage. Companions to the end, there were many accounts of the two gentlemen helping women and children into lifeboats. Both were in President Taft's inner circle; at their memorial service, the President tried to give the eulogy, breaking down in tears. A memorial fountain just below the White House on the Ellipse was dedicated in 1913 (*see insert*). Just blocks away was their 2000 G Street mansion, scene of many a party attended by the who's who of Washington society.

THE HOME OF KATHARINE GRAHAM: As owner of the *Washington Post* and the most powerful woman in the media, it was often said of Katharine Graham that "the road to the White House went through her Georgetown front door". When she died in 2001, her treasured wish to be buried across the street at the Oak Hill Cemetery Chapel was fulfilled. Her stone is on the far left, facing back towards her home and that famous front door.

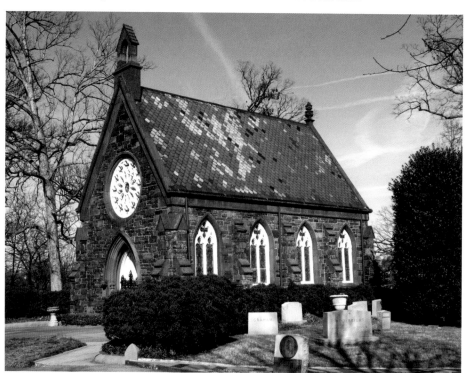

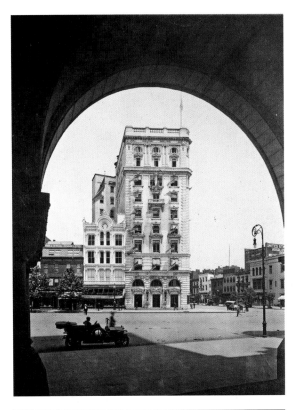

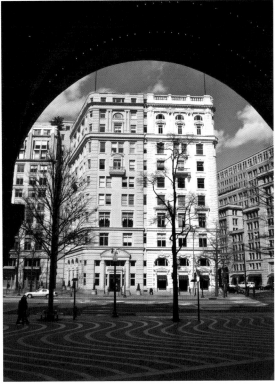

THE EVENING STAR
BUILDING: Caught in the arch of
the "Old Post Office Building" on
Pennsylvania Avenue NW, *The Evening
Star* was just around the corner from
The National Press Club. The paper,
established in 1852, went through a
series of owners and name changes until
it eventually settled on the *Washington
Star*. Even though it closed after 130
years, the building remains in tribute to
the hub of media activity. That stretch
of the Avenue was known as Newspaper
Row, and the term is perhaps still
appropriate as the new Newseum is
located a few blocks away.

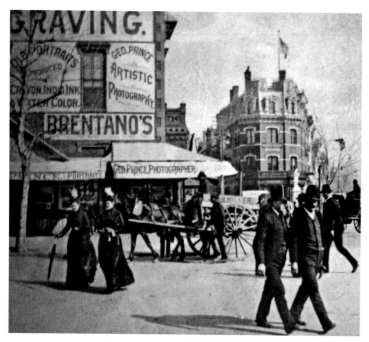

THE FBI BUILDING: An example of daily commercial life on Pennsylvania Avenue and 10th Street in 1901, in contrast to the stoic structure of the FBI building currently occupying the same blocks. But plans are under way for the "Hoover haunts" to relocate in the coming years, thus soon changing the character of the blocks again.

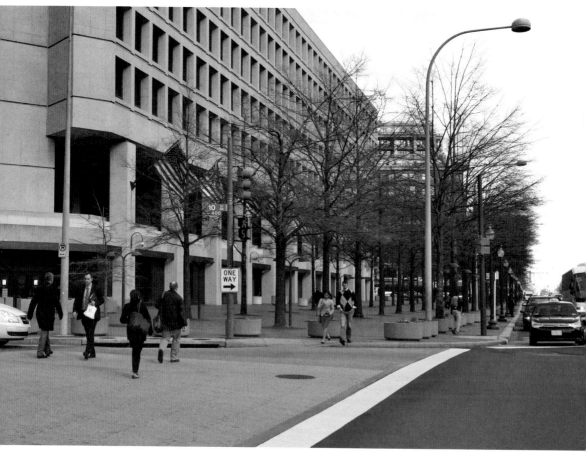

DIRECTING TRAFFIC
IN DC: In 1910 at the
intersection of 14th and
Pennsylvania Avenues, in the
6-mile stretch between the
White House and the Capitol,
was a collection of different
forms of early twentieth-
century transportation.
The horse-drawn streetcars
had been replaced with
electric ones, but plenty of
private buggies and early
autos competed for a traffic
policeman's attention.Note
the mirror on the stop and
go stand. Below, at 15th and
Pennsylvania Avenues, the
task is multiplied many times
over. The fashion statement is
for our brave policewoman's
protection as she directs
twenty-first-century traffic.

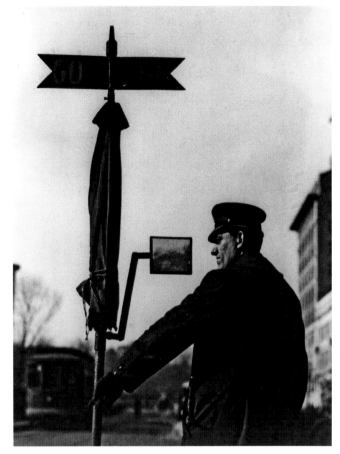

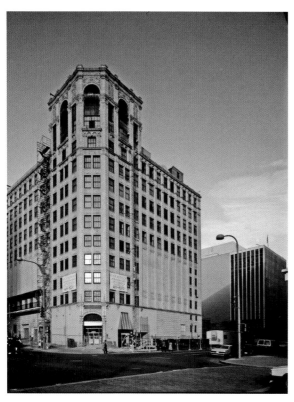

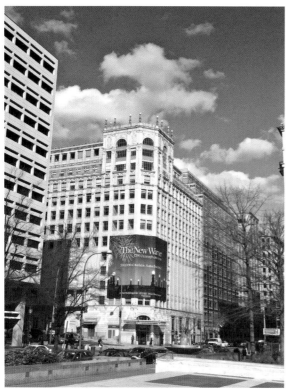

THE WARNER THEATRE: Built in 1924 as a movie palace and vaudeville house, the Warner Theatre is located at 13th Street and Pennsylvania Avenue NW. It went through a series of venues and revamps before this final restoration. Presenting theatrical and musical productions, it is also the home of the Helen Hayes Awards, in honor of the Washington DC native, as well as the BET Honors. Now named after its owner in the 1940s, Harry Warner, one of the Warner Brothers (studios), it features handprints of its performers in the sidewalk out front, and is situated just down the block from the National Theatre.

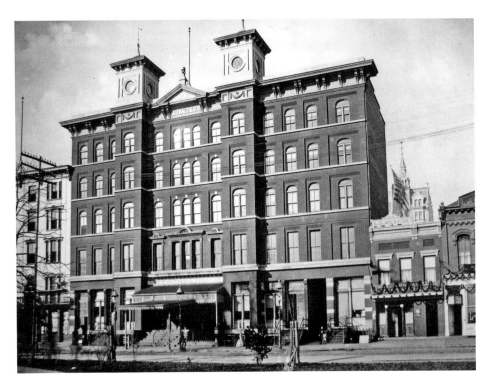

THE NATIONAL THEATRE: Located at the same address since it was privately established in 1835 at 1321 Pennsylvania Avenue, the National Theatre has been rebuilt several times after fires and refurbishing. The above photograph is from around 1886, and below is the current building which has been in place since 1923 and is built with some of the original steel, bricks, and reinforced stone foundations from its past structural performances.

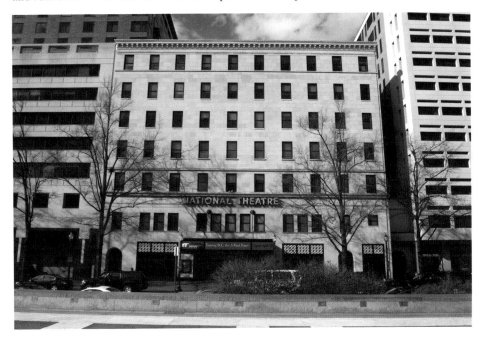

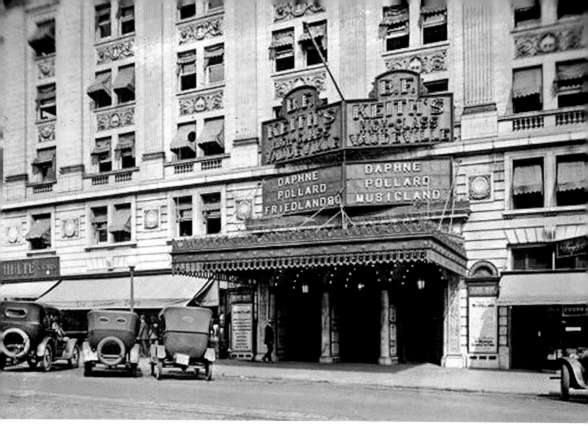

THE RKO KEITH THEATRE: One of the last vaudeville houses in the city, the RKO Keith Theatre was built in 1912 as "Chase's Polite Vaudeville Theatre" and renamed the following year as B. F. Keith's Theatre. It was then revamped in 1928 to also feature movies. It hosted many premieres with major stars like Fred Astaire and Ginger Rogers, with smartly costumed ushers and candy girls always on hand to serve the customers. It remained a movie theatre through several renovations until its final closure in 1978. Not until 1983 did the Old Ebbitt Grill move from around the corner on F Street to its present location; only the façade remains of the building's theatrical past.

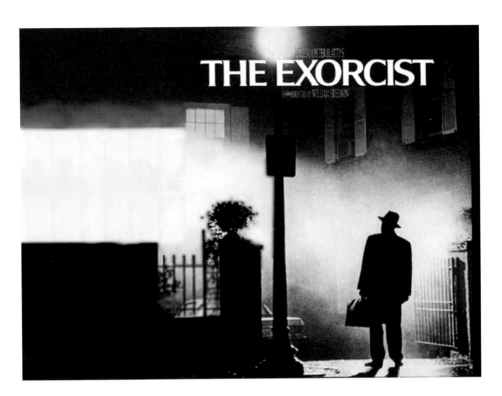

HOLLYWOOD ON THE POTOMAC: Washington has been captured in numerous films from *Mr. Smith Goes to Washington* in the 1930s to *The Day The Earth Stood Still* in the 1950s. But since 1973, fans still flock to the house of exorcism at 3600 Prospect Street, Georgetown, and the long flight of steps to the left leading down to M Street for the final scene. As for the exterior of the house itself, it was part actual house and part added constructed set.

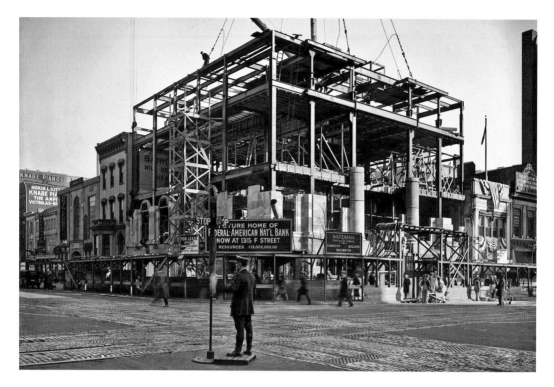

FUTURE HOME OF THE FEDERAL-AMERICAN NATIONAL BANK: On the corner of 14th and G Street, in 1925, rose the new edifice to the banking industry. This was also a main intersection for the streetcar traffic (from 1862 to 1962). Today, the tracks are long gone and the building is a mere shadow of its constructeda self.

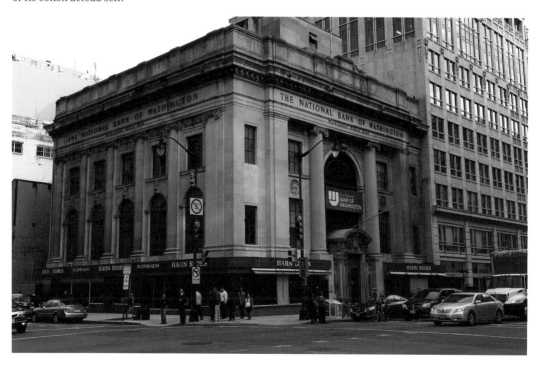

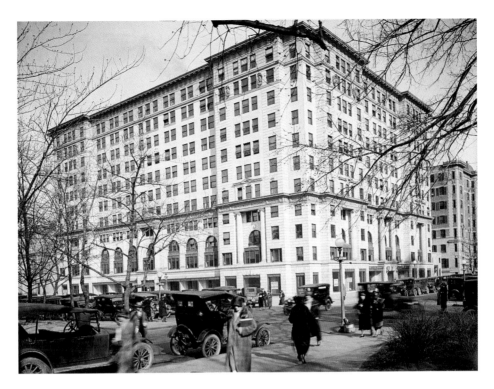

15ᵀᴴ AND K STREET: In 1922, DC saw the growth of large investment banking buildings along K Street. By the 1970s, "K Street" was known as a negative metonym for the lobby industry. Today there is but one lobby group on the street, but more traffic due to the closure of Pennsylvania Avenue in front of the White House, creating a diversion to K Street. At the busy intersection, traffic cops do their best to keep the flow by the same edifice.

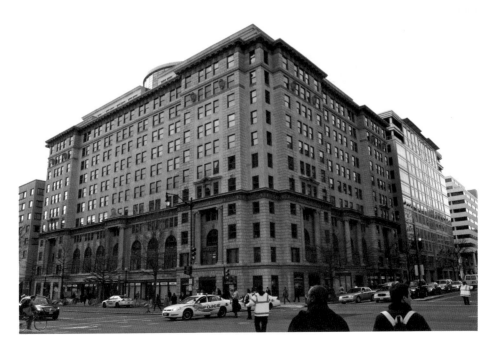

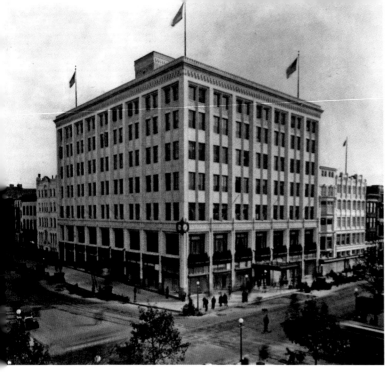

HECHT'S DEPARTMENT STORE: Opened in 1925 at 7th and F Street, Hecht's served a diverse community with the first elevator and the new auto population with the first parking garage. Today, renamed the "Terrell Place", it still sports its distinctive corner clock and is neighbors with the mega-sports arena, the Verizon Center.

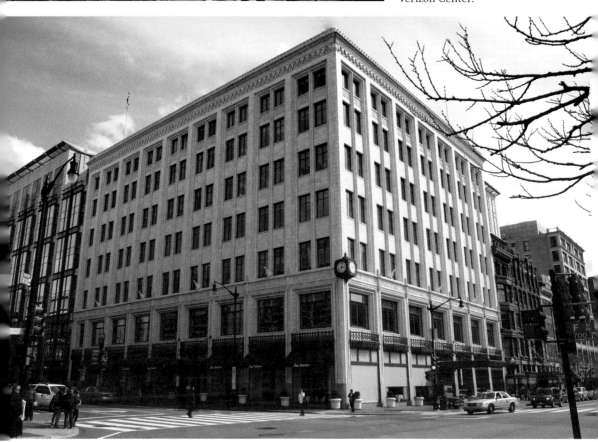

A "Kodak" look up 14TH Street: The innovation in photography of the new quick hand-held Kodak camera around 1885 allowed for a style of "snapshot" imagery, noted for its circle format. The two children pose for their father, Uriah Hunt Painter, in front of his photographic studio. Beyond the children is K Street and on the right, the Hamilton Hotel. In the photograph below, with a bit more traffic today, Franklin Square, to the extreme right, and the hotel, although enlarged, survive. The two "snaps" are exactly, to the day and spot, 124 years apart.

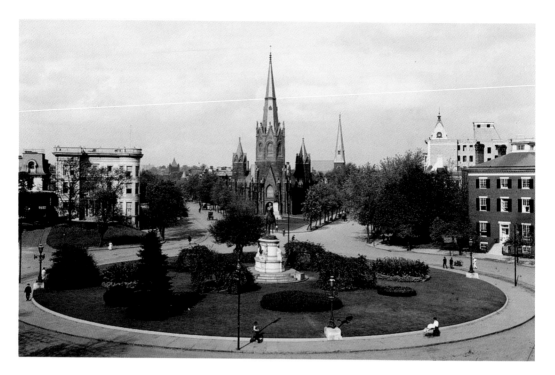

THOMAS CIRCLE: A glimpse of life on Thomas Circle 100 years apart. According to the US census, the population of Washington DC at the beginning of the twentieth century was 278,719; by the twenty-first century it had doubled, with an incalculable extra number of suburban commuters. Civil War General George Henry Thomas, mounted on his horse, has observed the "circular parade" since 1879. The circle is the intersect of 14th Street, M Street, and Vermont Avenue with the Massachusetts Avenue tunnel, finished in 1940, going beneath the traffic pattern.

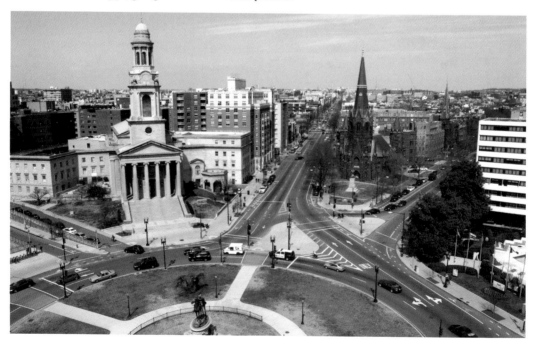

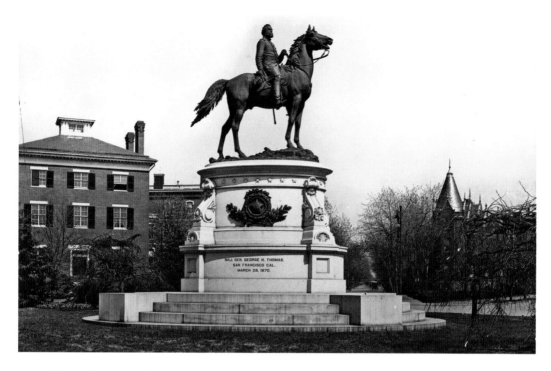

MAJOR GENERAL GEORGE THOMAS: The circle has honored its namesake since 1879 with this traditional equestrian statue. In the background is the Wylie Mansion, the home of Judge Wylie who presided over the trial of the assassins of Abraham Lincoln. The mansion at #10, built in 1843, survived until it was destroyed by fire in 1947. Today, gracing that same curve since 1962, is the Washington Plaza Hotel.

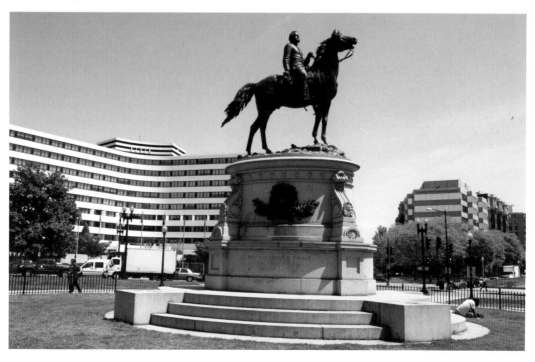

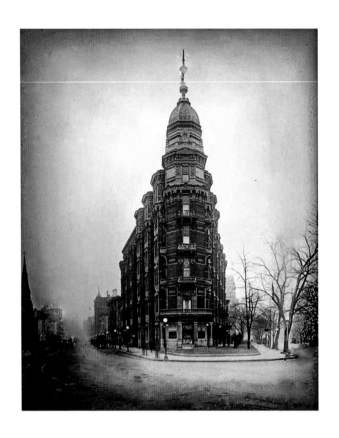

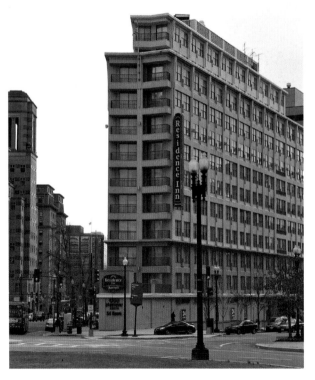

THE SOUTH CURVE OF
THOMAS CIRCLE: At the turn
of the twentieth century, the
downtown area of Washington
DC ended at Thomas Circle with
this ornate high-rise of the day.
The Portland Flats, built in 1879,
seen above soon after completion
as the first luxury apartments,
were a vanguard in the DC trend
of high-end housing. The unusual
pie shape of the lot, created by
the crossing of 14th Street and
Vermont Avenue, made for an
interesting architectural treatment.
The Portland Flats were razed in
1962, but not much can be said
about their replacement; perhaps
100 years from now it will be an
architectural wonder.

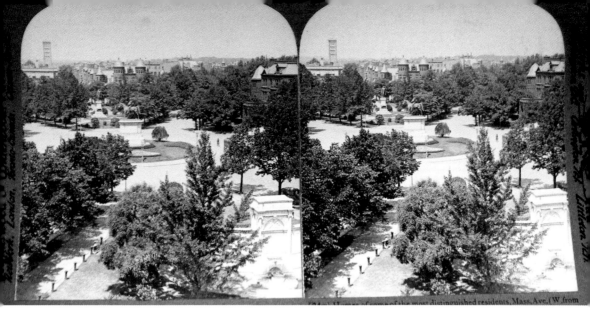

SCOTT CIRCLE: At the crossroads of 16th Street, Rhode Island Avenue and Massachusetts Avenue NW is the equestrian statue of Brevet Lieutenant General Winfield Scott, erected in 1874. The one-time defeated Presidential candidate stares, perhaps longingly, down 16th Street in the direction of the White House. He shares the circle with a monument to Samuel Hahnemann and the Daniel Webster Memorial. All three remain, but time has replaced all the homes with high-rise apartments and office buildings. The changes of horse and buggy to automobile traffic can be seen in a comparison of the stereo-optic of the late 1800s and the digital of today.

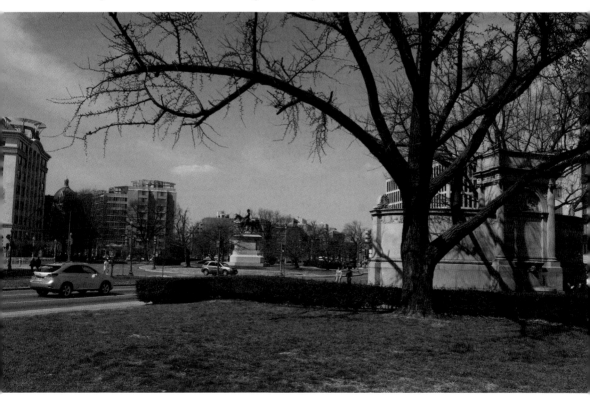

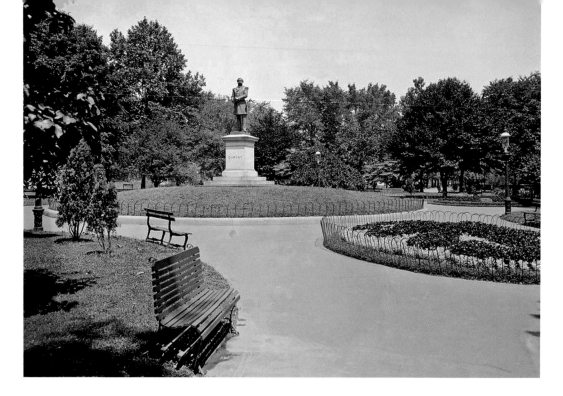

DUPONT CIRCLE: General Samuel Francis Du Pont, as with many Civil War generals, was to be honored for his Civil War service with a statue in a circle. So the original name, Pacific Circle, was changed in 1882 and his statue was dedicated. In 1921 it was replaced with the current grand marble fountain and the General was shipped off to Wilmington, Delaware, by request of the Du Pont family.

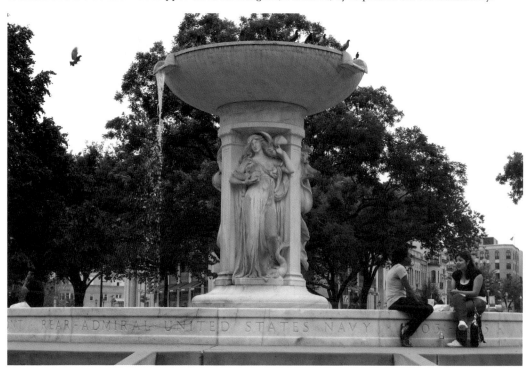

DUPONT CIRCLE, EAST SIDE: Over a hundred years apart, these photographs reveal in the background a white house, at #15, designed by famed architect Stanford White in 1901. It served as a temporary "White House" for President Calvin Coolidge in 1927 for six months during major repairs to the Presidential Mansion. It is currently known as the Washington Club, the first women's club incorporated in DC, and is dedicated to social discourse.

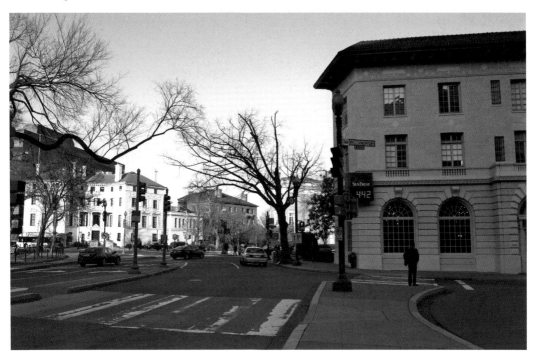

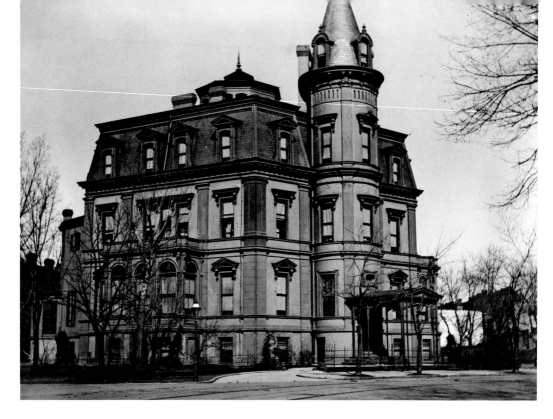

STEWART'S CASTLE: One of the first of the larger residences built on the Pacific Circle, now Dupont Circle, in 1873, was the home of Senator Stewart. "The Castle", so-called because of its size and design, was used as the Chinese Legation until 1893, before being demolished less than thirty years after its construction. Not until 1923 did the Riggs Bank construct their Dupont branch on the vacant lot, now a PNC Bank.

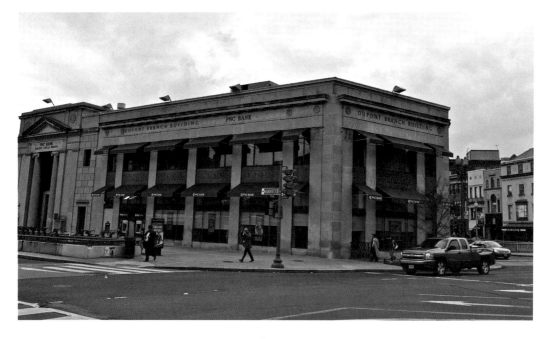

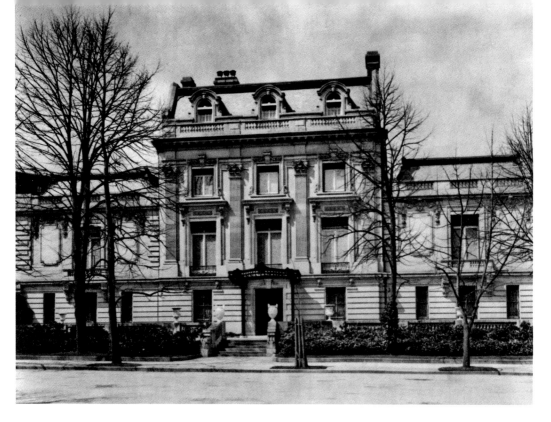

THE TOWNSEND MANSION OF 1899: Between Dupont and Sheridan Circles and representing one of the city's best examples of Beaux-Art residential architecture so popular in DC, the Townsend Mansion was built on the reclaimed land of the shanty houses, slaughterhouses, and brickyards of the 1870s. Seen here above in 1911, it would eventually be purchased by the Cosmos Club in 1950 and is still noted for its grand soirees and the extensive gardens.

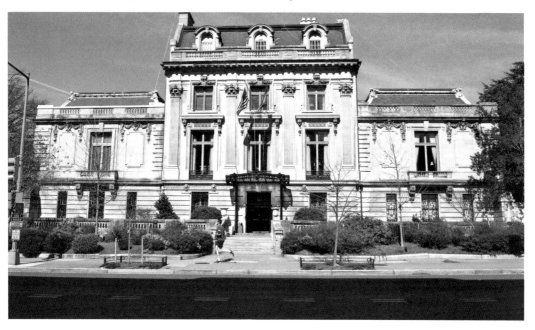

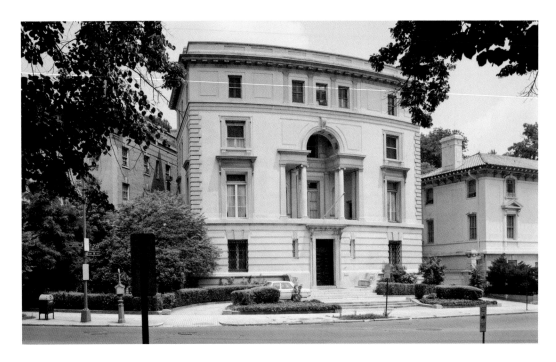

SHERIDAN CIRCLE: Built by the nouveau riche for entertaining during Washington's brief yearly social season, the Sheridan Circle was surrounded by the most fashionable addresses in DC. Eventually the maintaining of these enormous residences grew somewhat costly, and many soon were sold off for foreign embassies. The circle's namesake, Civil War General Philip Sheridan, was known for his instrumental role in forcing General Lee's surrender at Appomattox and serving as protectionist of Yellowstone Park. Although large in prominence, as reflected in his equestrian statue, "Little-Phil" was in fact only 5 foot 5 inches tall.

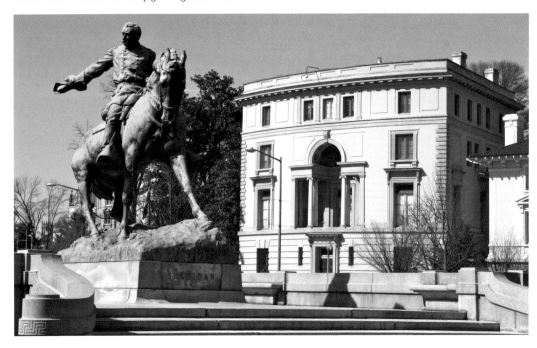

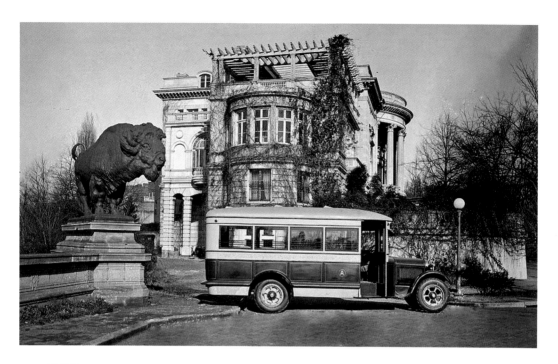

DC TRANSPORTATION: With the exception of the Metro, the best way for the public to get around Washington DC has not changed that much over the years, only the size of the buses have grown to match the size of the crowds. At the east end of the Dumbarton Bridge, aka the Bison Bridge, entering the Sheridan Circle neighborhood, we see the Turkish Embassy, formerly the Edward Everett show place. These homes in Sheridan Circle were the social hub of the early 1900s, and were designed to give parties. Buses still cross the bridge, and this one is on the way to Georgetown University.

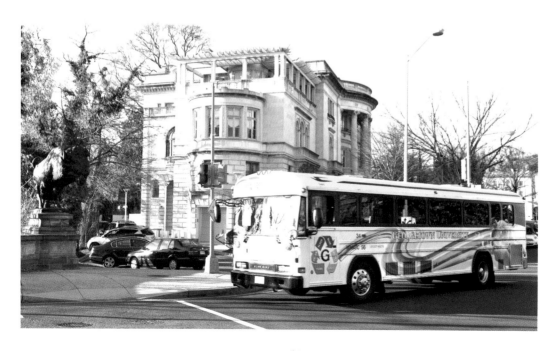

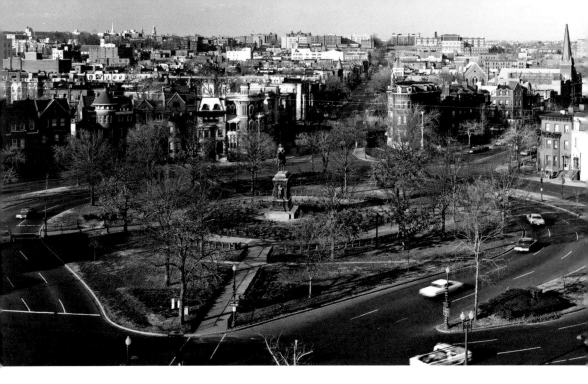

LOGAN CIRCLE: Originally called Iowa Circle, Logan Circle, just north of downtown, presents its grand sweep of large residential row houses. During the Civil War, it was referred to as Camp Baker before the barracks were converted to a refugee camp for freed slaves. By the Victorian era, with the swampy land drained, streetcar tracks laid, and elm trees planted, development was encouraged. Several traffic patterns around the circle have been attempted, as a statue of General Logan looks on.

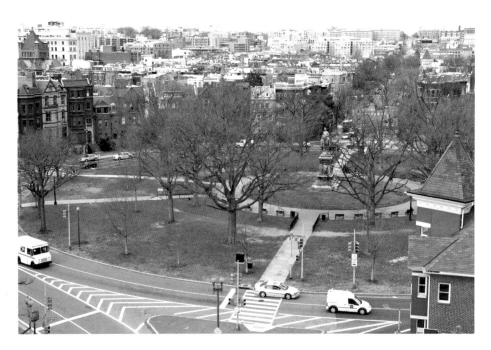

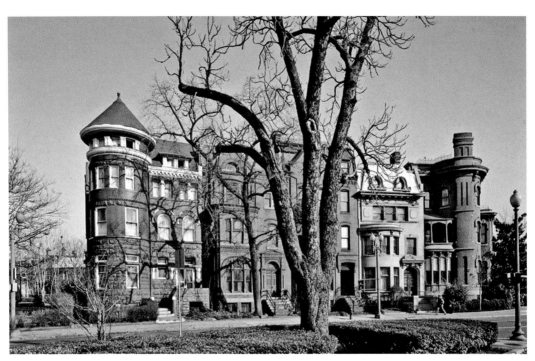

THERRELL SMITH OF LOGAN
CIRCLE: Logan Circle's most lovely
treasure is not a house but a Miss
Therrell Smith. As a child she moved
with her family on to what was then
Iowa Circle, and witnessed first hand
the evolution of her neighborhood. Her
father, Dr. T. C. Smith, had his practice
just below his grand home, and upstairs
Miss Smith would practice her dancing.
Eventually studying in New York and
Paris, Therrell returned to the circle to
become one of Washington DC's most
famous dance teachers. She continues
to teach the art, and at ninety-five, she
gave a dance performance of celebration
and style. One cannot help but bow to
that style, demonstrated here as she
views her circle.

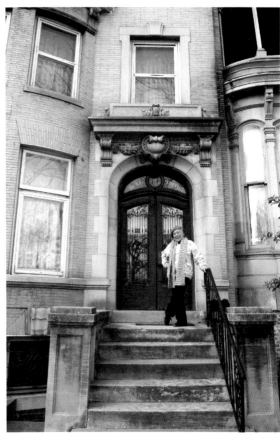

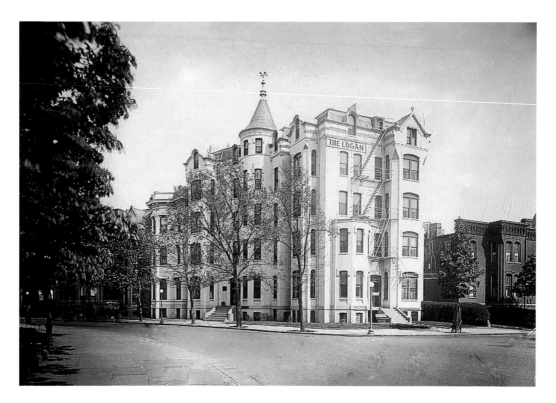

"THE LOGAN": Commanding the southeast curve of the Logan Circle for years, the Logan apartments were the exception on the circle, which consisted of mainly large single-family homes. Its demise (no one seems to remember why, not even Miss Smith, *see page 61*) left a vacant lot for years, until row-house-style condominiums were constructed at the beginning of the twenty-first century.

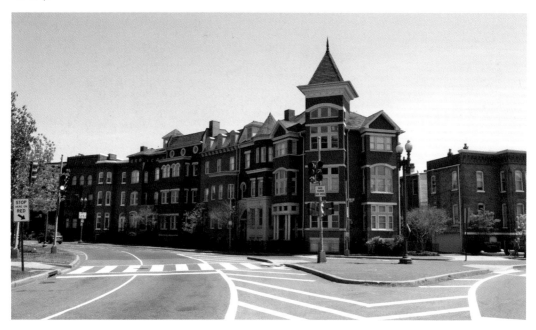

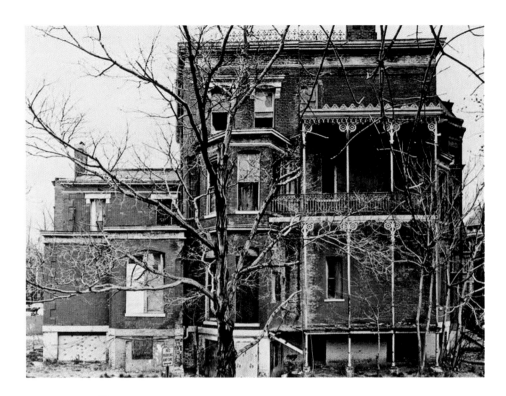

THE LOGAN HOUSE: Number 4, Iowa Circle, shown in sadder days, was the residence of the American Civil War hero General John "Blackjack" Logan, who lived here from 1885 until his death the following year. He represented Illinois as Congressman and Senator, and in 1884 he campaigned unsuccessfully for the Vice Presidency. He helped spearhead the establishment of the Memorial Day remembrance. Today, Logan Circle honors him with a statue, a neighborhood, and a restored home.

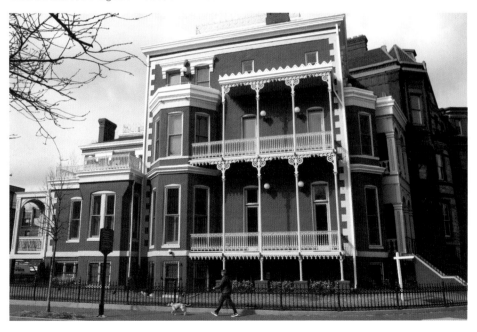

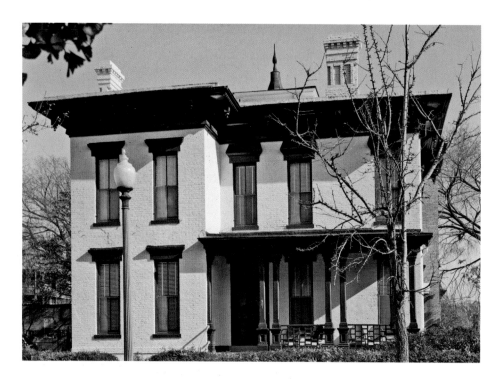

LEDROIT PARK: Established in 1873 as one of the first suburbs of Washington DC, LeDroit Park was originally a gated "whites-only" community until 1888, when pressure from neighboring Howard University helped integrate the community. The neighborhood contains one of the smallest "circles", named after the prominent black educator, Anna Julia Haywood Cooper. Of the original sixty-four "Victorians", restoration and diversity is exemplified proudly by the remaining fifty homes.

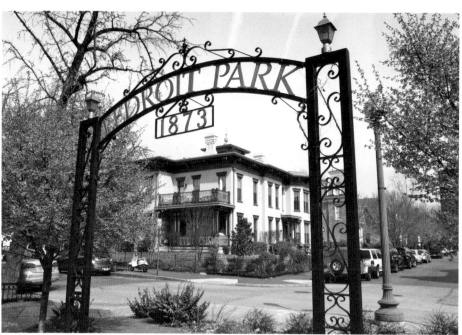

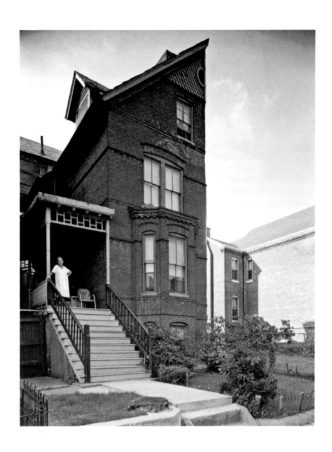

THE HALF A HOUSE: Waiting and hoping to be restored is one of the oddities of LeDroit Park. It is the surviving half of a duplex at 326 T street NW. Built in 1894 and known as the Mary Church Terrell House, the adjoining house was lost to a fire in the 1940s and demolished. Mary Church Terrell, born a daughter of former slaves in 1863, was one of the first black women to receive a college degree. She was pivotal in fighting for suffrage for women in the 1920s and in eliminating segregation in DC schools and restaurants in the 1950s. The neighborhood keeps faith that one day the boards will come off the windows.

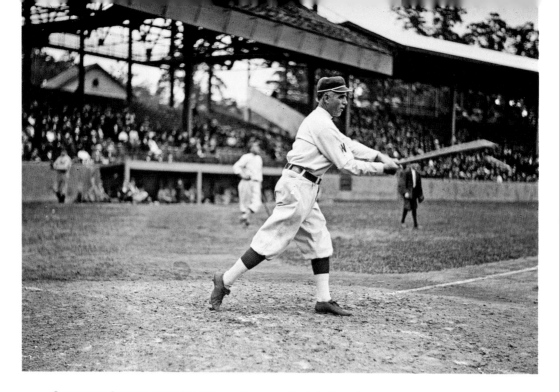

GRIFFITH STADIUM VS NATIONAL PARK: Clark Griffith (player/eventual owner) swings away at the newly rebuilt steel stadium in 1913, which loomed adjacent to LeDroit Park NW. The stadium and neighborhood is the backdrop of the Broadway Musical hit set in 1950s DC, *Damn Yankees*. The National Club of Washington DC was formed in 1859, just thirteen years after the first rules of the game were established. Over the years, the team's names of "Nationals' and "Senators" seem to have been used interchangeably. Originally situated where Howard University Hospital is today, the new park built on the Anacostia River has not only energized a new team and sports fans, but sparked redevelopment in the southeast quadrant of the city.

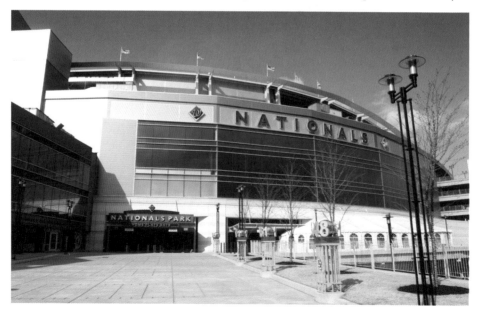

WASHINGTON CIRCLE: The first traffic circle in the city, Washington Circle was created in 1856 at the crossroads of K Street, New Hampshire, and Pennsylvania Avenues NW. The statue of General Washington looks down on the soldiers in April 1865 – the line of defense for the city during the Civil War, excluding, of course, the two little neighborhood girls with hoops on the end. Below, surrounded by GW University and GWU Hospital, the General observes the traffic and pedestrian flow through the Foggy Bottom neighborhood.

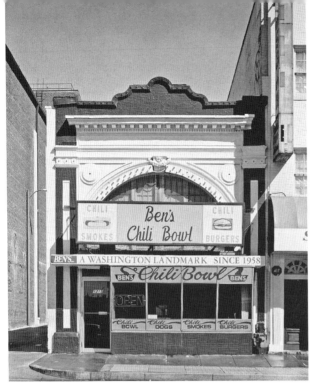

BEN'S CHILI BOWL: Amid the nightlife of U Street, seen here in 1971 and then again now, is one of the most popular survivors of its near sixty-year vantage point in the changing neighborhood. From the riots of 1968 to the building of the Metro and the recent gentrification, loyalists go for the "original chili half-smoke" and use it as a "welcome to the city" treat for visitors. The Mayor of DC brought President-elect Barack Obama to Ben's for such a welcome, and Bill Cosby doesn't miss a visit, nor a half-smoke "The Cos style", when he is in town.

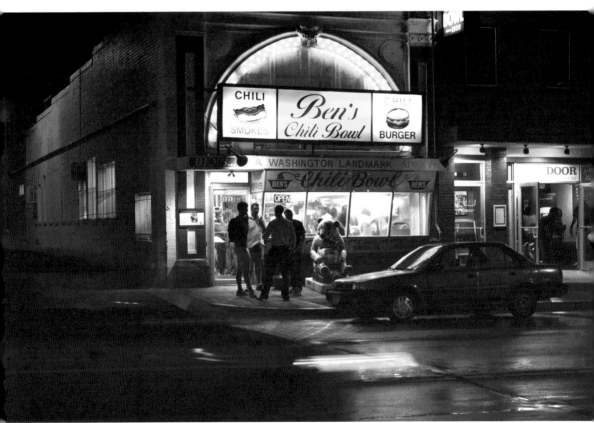

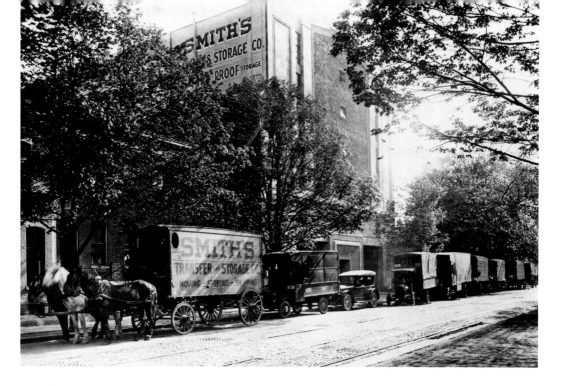

SMITH TRANSFER: The three major moving companies in DC at the turn of the twentieth century, all located near 14th and U Street, were Federal Security, Fidelity Storage, and Smith Transfer. Remnants of Fidelity can be seen in the faded 1905 sign on the "U-storage" at 1420 U Street, but Smith, established in 1909, as seen above, became a casualty of the Metro tunneling in the 1970s. The lot remained vacant for decades until replaced by the Ellington condo and restaurant complex at U and 13th Street.

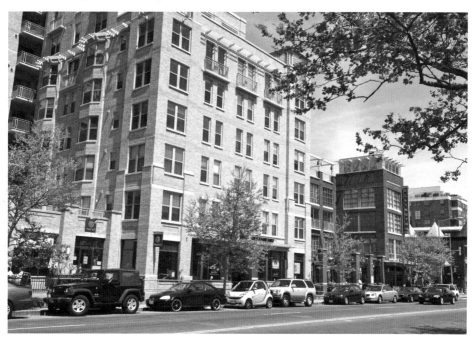

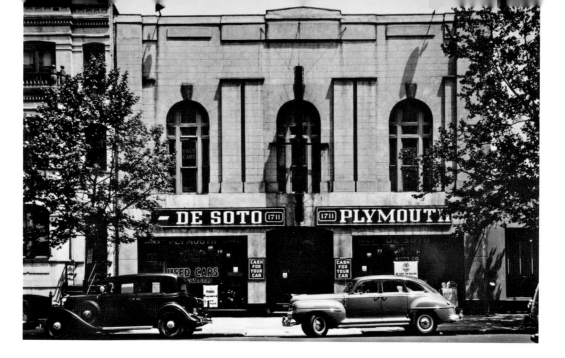

"AUTO-ROW": In the 1920s and '30s, 14th Street NW was the place to go for the holiday arrival of the new automobile models, as well as for finding replacement parts for the family car being kept for "one more year". It was not unusual to see stacks of tires or radiators on the sidewalks outside shop after shop, lining the street where today there are crowded café tables. Washington was one of the top markets in the country for auto sales. Many of the shadows of former showrooms remain, as in this case, part of "The Whitman Walker Health, Elizabeth Taylor Medical Center", seen here. A couple of the condo complexes in the area have been named to honor popular auto models, such as Hudson and De Soto.

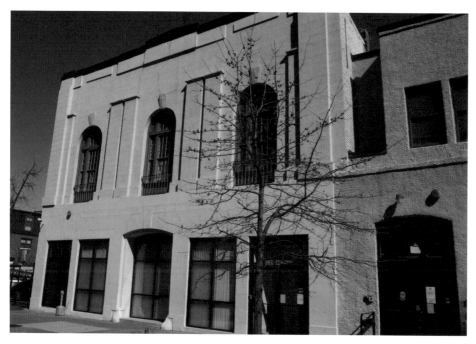

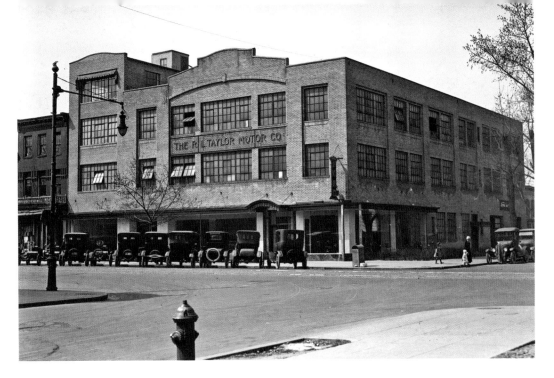

14TH AND T STREETS, NW: These large auto showrooms would evolve over the years. The Taylor Motor Car Company of 1923, which supplied DC with Fords, would spend several years as a church before becoming this "Room and Board". Some of the more spacious structures were perfect for theatres and complexes, such as the Studio Theatre.

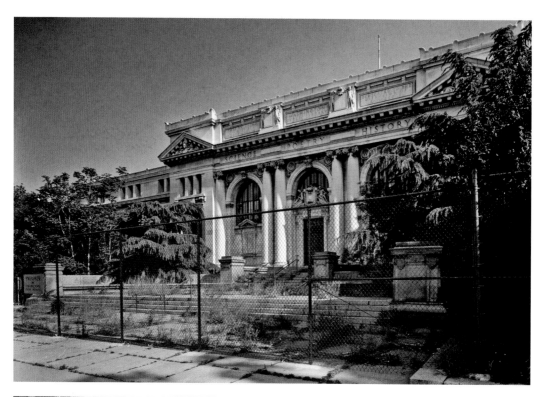

THE CARNEGIE LIBRARY: A gift to the city of Washington DC by philanthropist Andrew Carnegie, the library was built in Mount Vernon Square and dedicated on January 7, 1903, serving the community for seventy years. Not until 1998 did the building, restored, become the Historical Society of Washington DC. Surrounded in shadows by the New Convention Center to the north and downtown office complexes to the south, it is architecture in contrast.

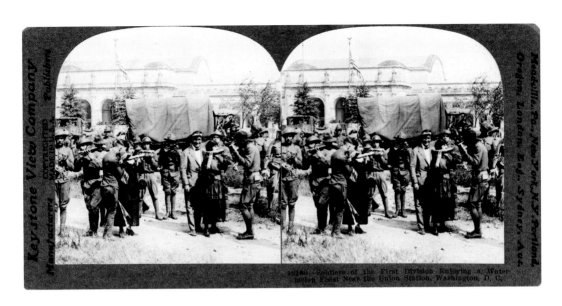

WATERMELON FEED AT UNION STATION: A stereo-optic of World War I troops being provided with melons as they pass through Union Station. Prior to the station's opening in 1907, each of the major railroads had their own stations and tracks situated on what today is the National Mall. Now a trip to the station may include the restaurants or the food court, or even the shopping mall. The architecture, in the Beaux-Art style, was restored in 1988 and is in continued preservation.

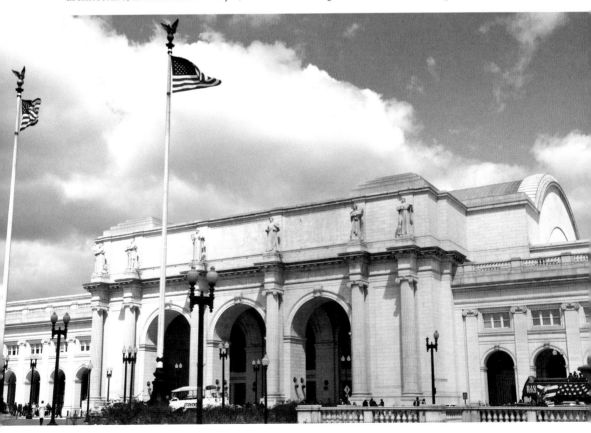

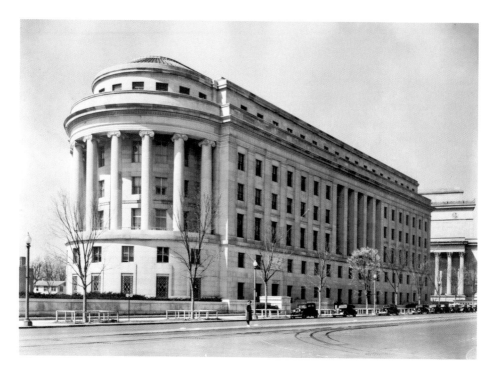

"MAN CONTROLLING TRADE": The completion of the Federal Trade Commission building in 1938 was to symbolize architecturally the stability of US trade. Fitting grandly on the triangular lot at Constitution and Pennsylvania Avenues, an atrium design allows light into the interior offices. By 1942, through the WPA funding the arts, Michael Lantz created two non-identical massive sculptures for either side of the semicircle protocol called "Man Controlling Trade" (*see insert*). Lantz was the brother of Walter Lantz, famed cartoonist and creator of Woody Woodpecker.

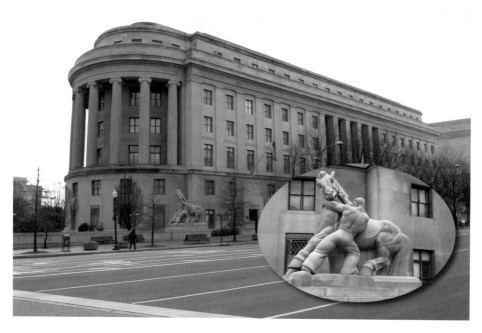

THE OLD PENSION BUILDING: Built between 1883 and 1887, unlike any public building in DC, all around the structure of the Old Pension Building the exterior frieze depicts and honors the Civil War veterans that the US Pension Bureau was put in place to serve. Inside, supported by immense Corinthian columns, among the tallest interior columns in the world, is a massive open space. Today, the columns support the National Building Museum. Below, on the south side of the museum is the National Law Enforcement Officers' Memorial.

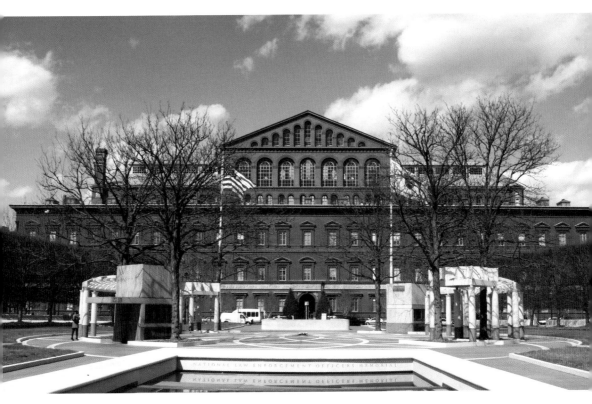

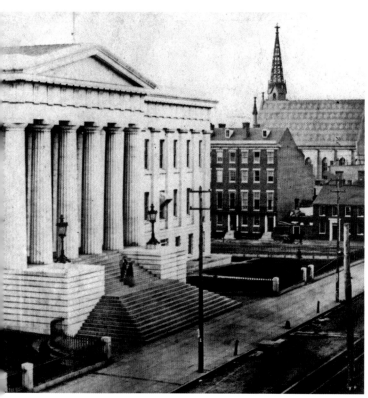

THE US PATENT OFFICE OF 1885: The Greek Revival building's construction was started in 1836 and took thirty-one years to complete. It was built to house scale models of all the nineteenth-century inventions submitted by their inventors. For a while during the Civil War the building was used as military barracks and hospital, where often poet Walt Whitman would read to the wounded lying on cots among the glass-cased models. Unfortunately, it also served as a morgue. Today, as part of the Smithsonian, the building houses the National Portrait Gallery and American Art Museums.

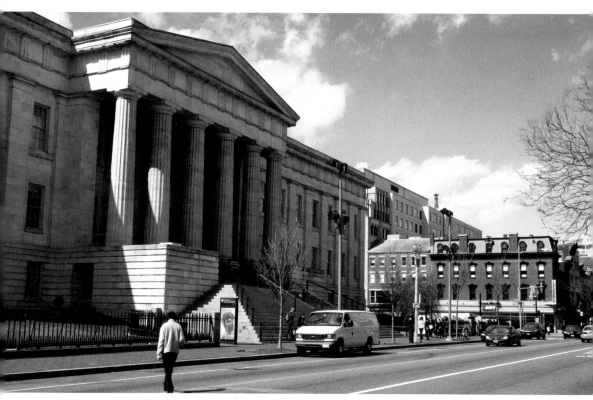

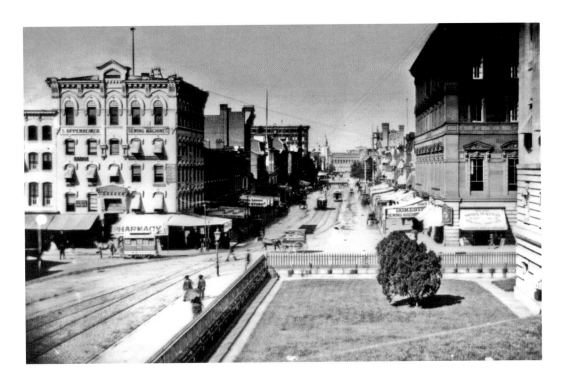

F STREET OF 1880: The view down F Street from the vantage of the Old Patent Office, now the Smithsonian American Art Museum, between 7th and 9th Avenues. In the distance, beyond the horse-drawn vehicles and the sewing machine companies, can be seen the newly completed Treasury Building. Below, note to the right the blue "Modern Head" sculpture by Roy Lichtenstein, retrieved after 9/11 with a few scratches from Battery Park, a block from the former World Trade Center.

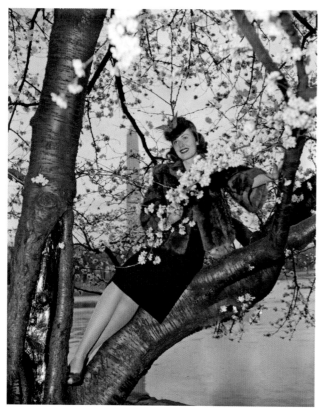

CHERRY BLOSSOMS ALONG THE TIDAL BASIN: Peggy Townsend poses for press in anticipation of being crowned 1939 Cherry Blossom Queen. The annual festival celebrates the gift from Tokyo in 1912 of the beloved trees to Washington DC and President Taft. Upon the arrival of the initial 2,000 trees, inspectors discovered that they were infested and "had to be destroyed". The successful second attempt of importing 3,020 trees is what now draws the spring crowds to DC, providing Kodak moments of the blossoms framing the Washington Monument and Jefferson Memorial.

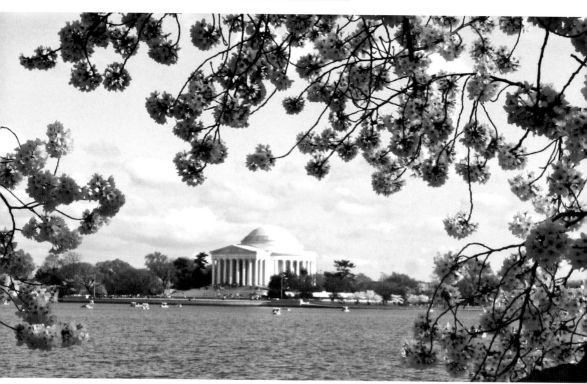

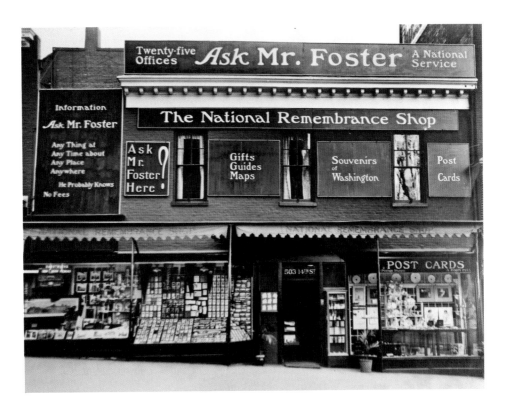

THE NATIONAL REMEMBRANCE SHOP: Walking on the downhill slope at 14th Street and Pennsylvania Avenue NW in the 1920s, tourists visiting Washington DC could find souvenirs and post cards of their trip. They could also find the stereo-optics seen throughout this book. Although not Mr. Foster's, on this very corner and part of the Marriott complex is a "remembrance shop" of the twenty-first century.

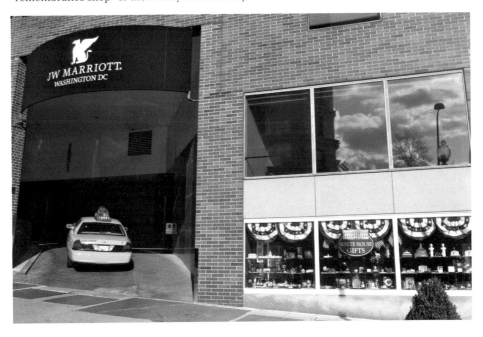

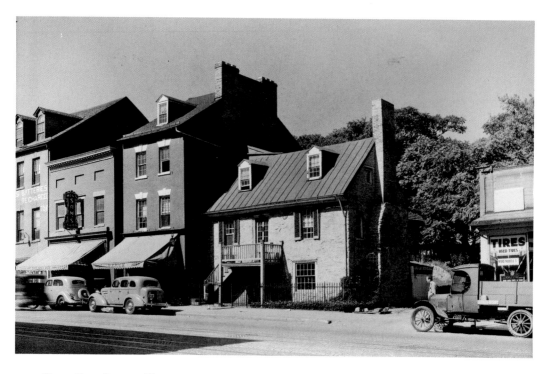

THE OLD STONE HOUSE: A pre-revolutionary, ordinary citizen-inhabited home. It has survived in its original location in Georgetown on M street unchanged since 1765. Seen here in 1934, its survival is attributed to "untrue" folklore about George Washington meeting there with Pierre L'Enfant while planning the Federal City. Busy shoppers hurry by, visiting the many retail establishments of today.

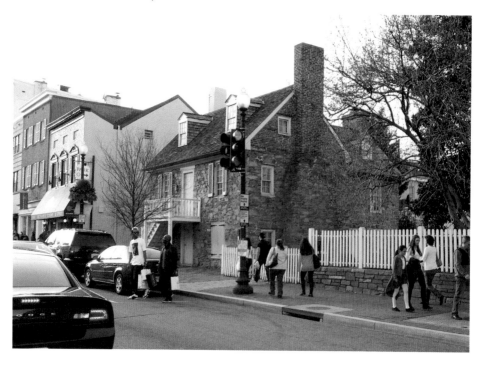

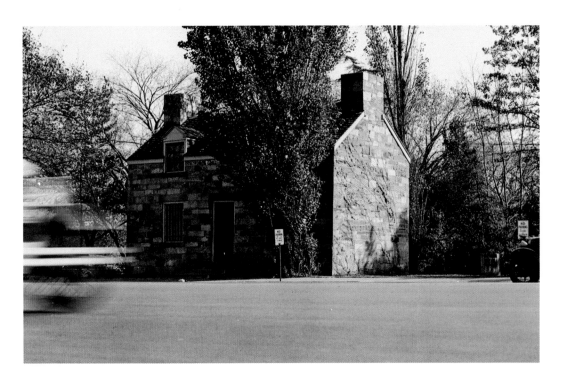

THE LOCKKEEPER'S HOUSE: At 17th and Constitution Avenue, a little stone house that millions of cars and tourists have gone by over the years is all that remains on the mall of the canals of two centuries ago. Started in 1809 and opened by 1815, the canals were the eastern connection for the Washington City Canal from the C&O, moving goods in and out of the city. The lockkeeper's house was built in 1835 to collect tolls and keep commerce records.

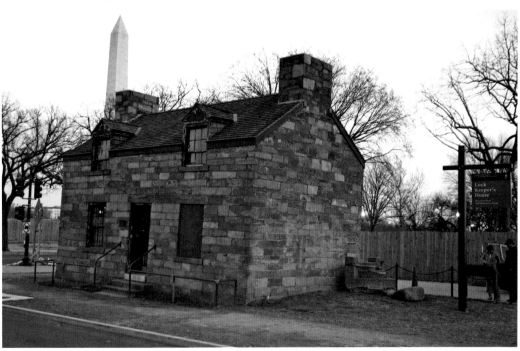

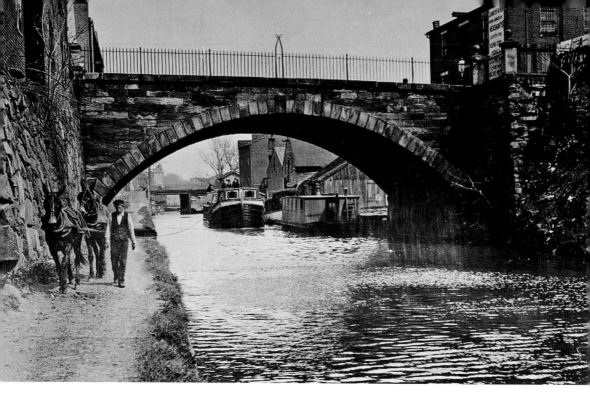

THE BRIDGE OVER THE C&O CANAL: Mules are walked back from their service of pulling the barges up the canal. The offspring of a donkey and a horse, mules were brought to this country as a gift of King Charles of Spain at George Washington's request in 1785. Washington, the first US owner of a mule, had heard that the animal worked half again as hard as a horse, but ate less, and was perfect for farm work. With the barges a thing of the past, the beaten paths are perfect for Georgetown joggers or afternoon strolls.

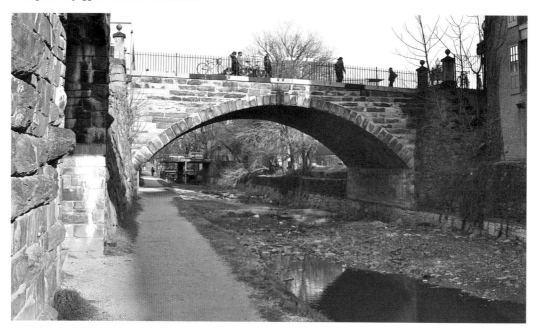

THE C&O CANAL GEORGETOWN
PATH TO TOWN: The canal itself
operated from 1831 to 1924 and
was an important goods shipping
lane along its 184.5-mile length.
The section through Georgetown
has been preserved as an example
of early nineteenth-century
waterway transportation. It would
have connected to the Washington
City Canal system and served the
growing Federal City. Bike paths
and walking trails, which replaced
where mules would pull the canal
barges, have created a picturesque
public space – a far cry from initial
plans to develop the space into a
parkway for the use of automobiles.

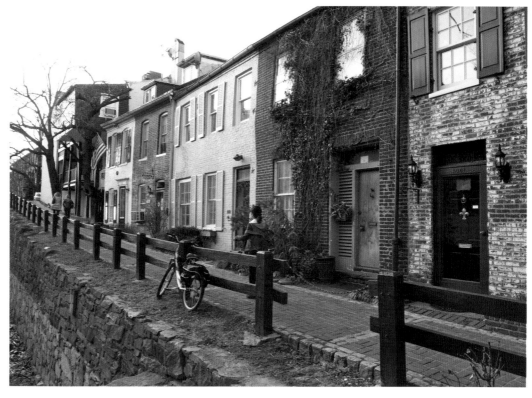

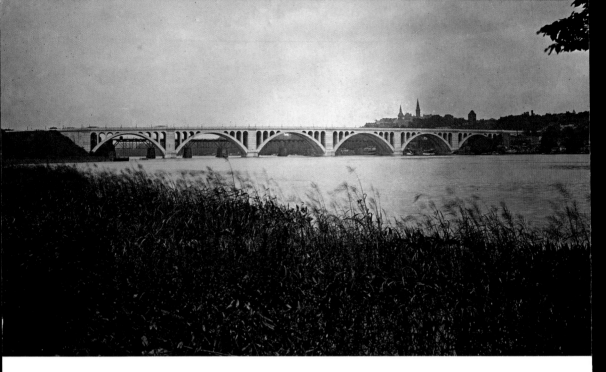

THE FRANCIS SCOTT KEY BRIDGE: With the spires of Georgetown University rising on the right, the above view, photographed soon after the bridge's completion in 1923, is from the beach on the banks of the Potomac on Anacostine Island. Today, from that beach on the island, renamed Roosevelt Island in 1931, there are a series of crossing footpaths leading around a monument to the twenty-sixth President, Theodore Roosevelt.

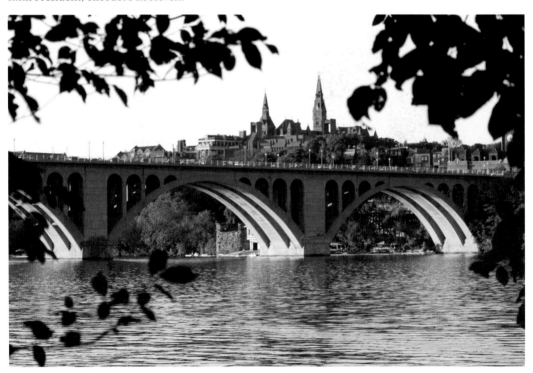

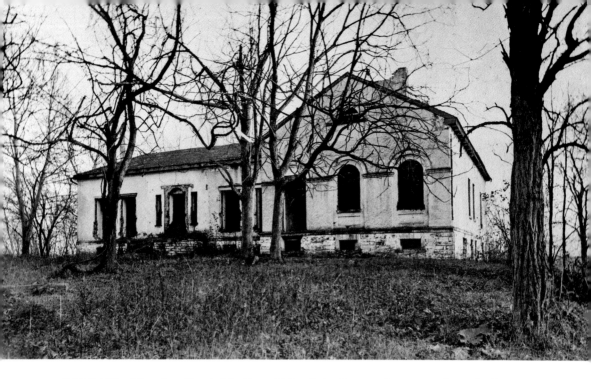

ROOSEVELT ISLAND: Situated in the middle of the Potomac just across from the Georgetown waterfront, the 88.5-acre island dating back to 1668 was named Anacostine Island. Around 1796, John Mason built his house, seen here in 1910, and developed the land by planting gardens, but scarcely an impression of the foundation or anything other than native vegetation remains. Now, the main edifice on the island since 1932 is the monument to Theodore Roosevelt.

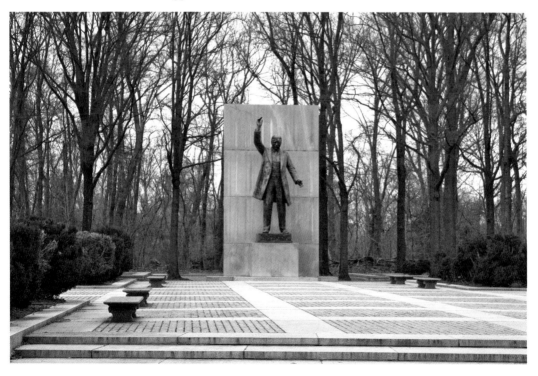

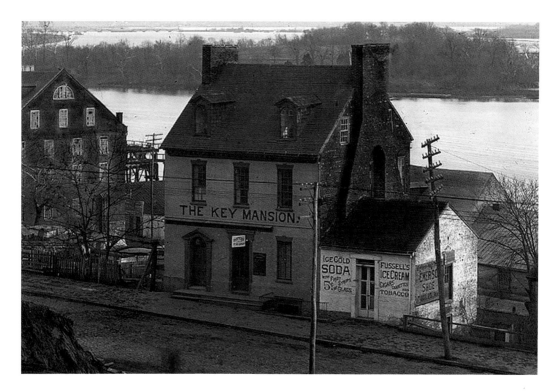

THE KEY MANSION IN GEORGETOWN: The home, from 1803 to 1833, of Francis Scott Key, lawyer and poet, was dismantled in 1947 and lost in storage by the Parks Department. A lovely park and the adjoining Key Bridge now honor the man who composed "The Star Spangled Banner", the US National Anthem. In the background is Anacostine Island, and barely visible is the Mason Mansion.

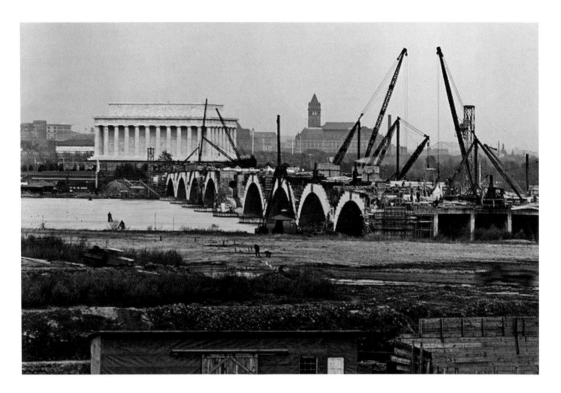

THE ARLINGTON BRIDGE: Although first proposed in 1886, the Arlington Bridge construction was authorized in 1925 after several design and name changes and finally completed for opening in 1932. The center section of the neoclassic span was a bascule bridge (drawbridge) for larger shipping to Georgetown, but no longer needed, it ceased being opened on February 28th, 1961. Today, the bridge is the ceremonial entrance to Arlington Cemetery.

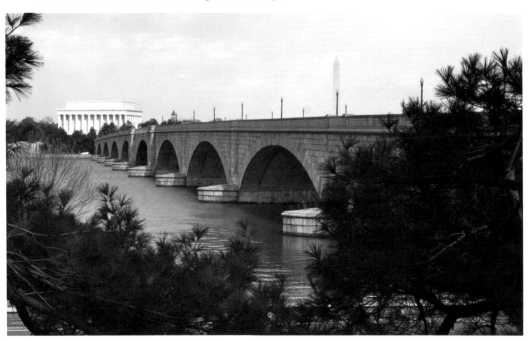

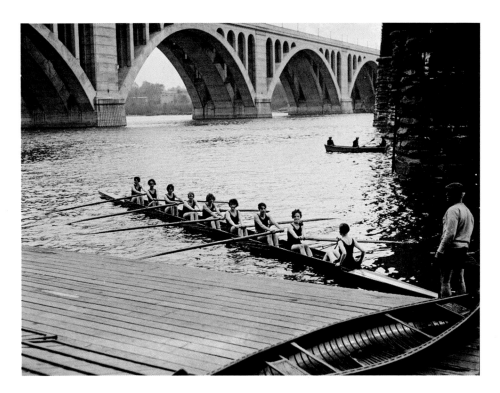

CREWING ON THE POTOMAC: The water may be freezing, but one of the sure signs of the coming spring in 1922 was the appearance of competitive crew teams on the Potomac. Not much has changed since these eight women (nine including the cox), in perfect coordination, glided through the water in a sweep boat (each rower has one oar), with a coach with a megaphone in a launch or spotter boat nearby and that of their counter-part 90 years later.

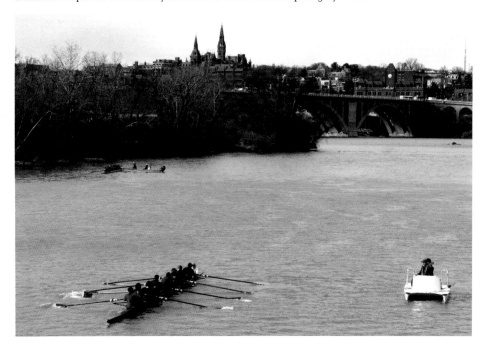

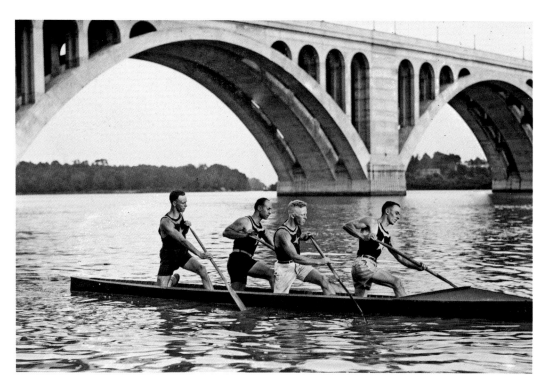

ROWING ON THE POTOMAC: A long tradition of rowing on the Potomac River dates back to the forming of the Potomac Boat Club in 1869. Above are men rowing beneath the newly completed Key Bridge in the 1922. Today, competitive rowing carries on that tradition with the Club Rowing Committee still active on the river along with the Capital Rowing Club, Thompson Boat Center, and the Alexandria Community Rowing.

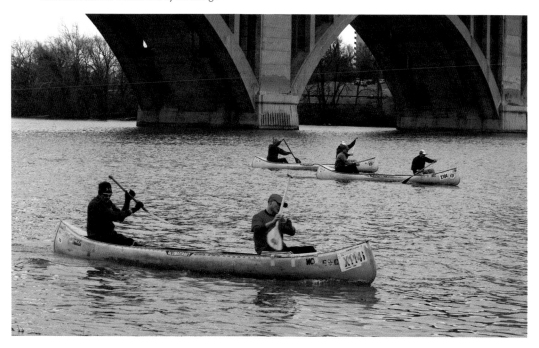

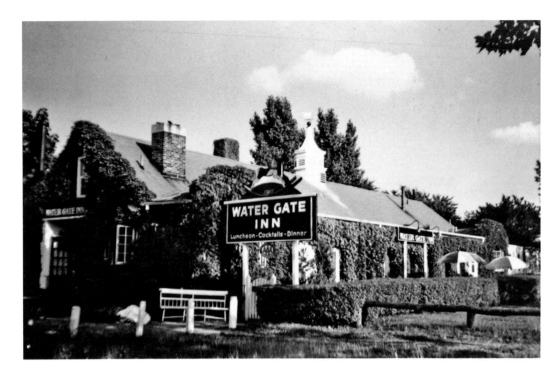

THE WATER GATE INN: Operating from 1942 to 1966 on the site of what is now the Kennedy Center of Performing Arts was the tavern, unique to DC, of Pennsylvania Dutch-inspired cuisine. A favorite of Eleanor Roosevelt, it quickly became very popular as an "off the beaten track" eatery. "Water Gate" came to have a very different meaning with the political break in at the Watergate Complex in 1972, and the press latching onto a cleaver phrase. But the name simply refers to this area where Rock Creek empties into the Potomac River. Below is both the Watergate Complex and the Kennedy Center.

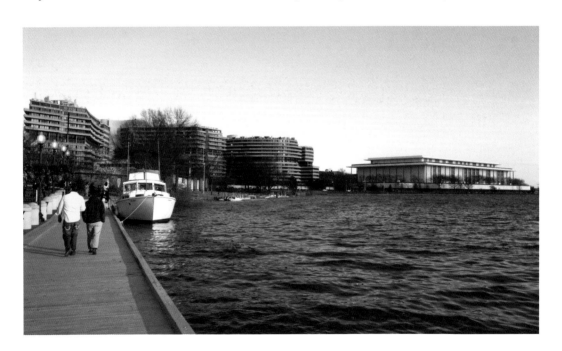

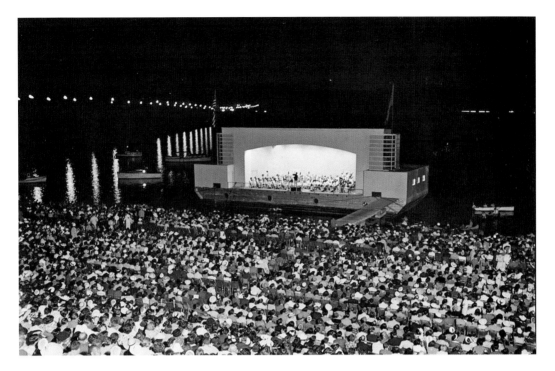

"AND THE BAND PLAYED ON": The forty stone steps leading up from the Potomac to the Lincoln Memorial, originally conceived as a ceremonial entrance to the city, became the stone seats, along with folding chairs on the closed Ohio Drive, for music lovers. There, staged on a floating barge, on July 14th, 1935, the National Symphony Orchestra played as the sun set. "The Sunset Symphonies" caught on and continued until 1965 when the noise of jet planes from the National Airport ended the enjoyment. (Note: The opening scene in the Cary Grant movie *Houseboat* takes place at the Symphony on the Watergate steps). The steps are now used mainly by joggers, but it is still a good spot to watch the sunset.

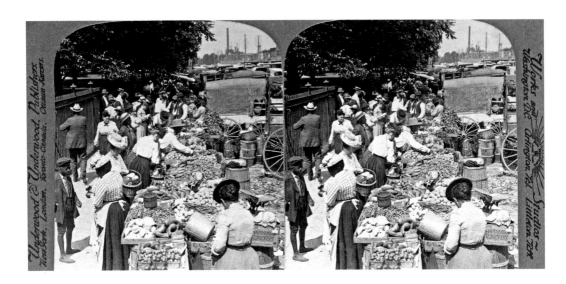

THE EASTERN MARKET: The above stereo-optic is of the Old Centre Market located at Pennsylvania and 7th Avenue NW in 1904, where the National Archives is today. It was one of three main farmer's markets in DC. City folk did their fresh open-air marketing right off the farmer's wagon. The only one that remains is the Eastern Market up on Capitol Hill, where the bustle of the market place has been a tradition since 1873. Restoration and a new generation of weekend marketers have ensured the tradition will continue. Inside, beyond the "fresh from the neighboring farms" produce, are butchers and bakers to delight the shopper. Outside are also flea markets with unknown treasures, while nearby restaurants are providing Sunday brunch specials.

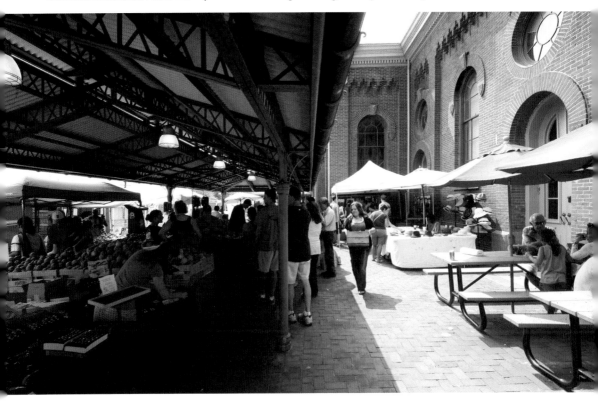

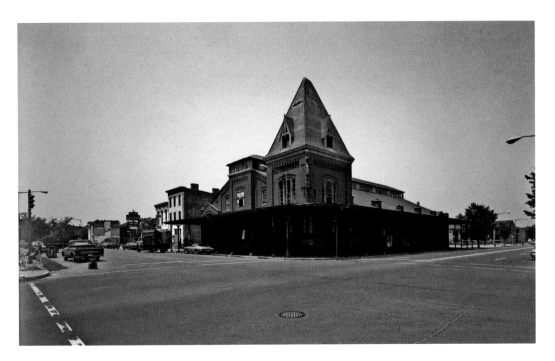

THE O STREET MARKET: First serving the Shaw Neighborhood in 1881, the O Street Market has been waiting for restoration since it was declared a DC historical site in 1968. It had been slowly deteriorating; even the roof had collapsed in 2003, but it was one of three remaining nineteenth-century markets (Eastern Market and Georgetown Market) still standing in the district, if barely. Now it is to be part of a million-square-foot housing, hotel, and retail complex. The old O Street Market, renamed "City Market at O", will once again be the place to go for one's "major-marketing".

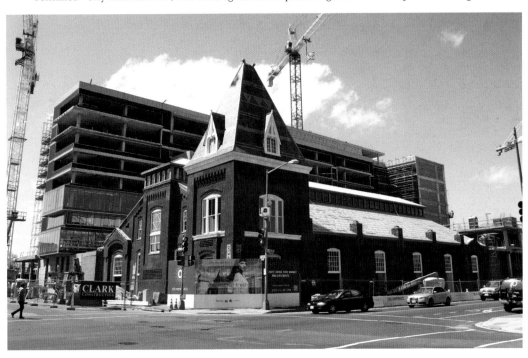

93

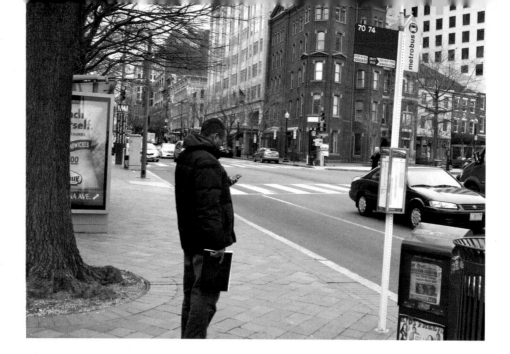

CALL BOX VS. CELL PHONE: A gentleman makes a cell phone call at 7th and Pennsylvania Avenues. A century before, a peace officer in the same spot places a call to police headquarters from one of the many call boxes first introduced in DC in 1883. Boxes were available for both the police and public. By 1910, as below, they were keyed and exclusively for police use only. They have since been refurbished by a program of Cultural Tourism in DC, as "Art On Call", or for neighborhood history markers.

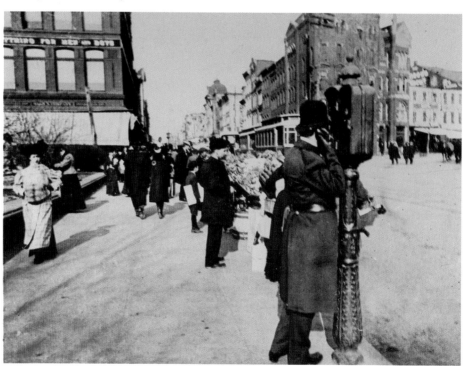